Robert

Davidson:

Haida

Printmaker

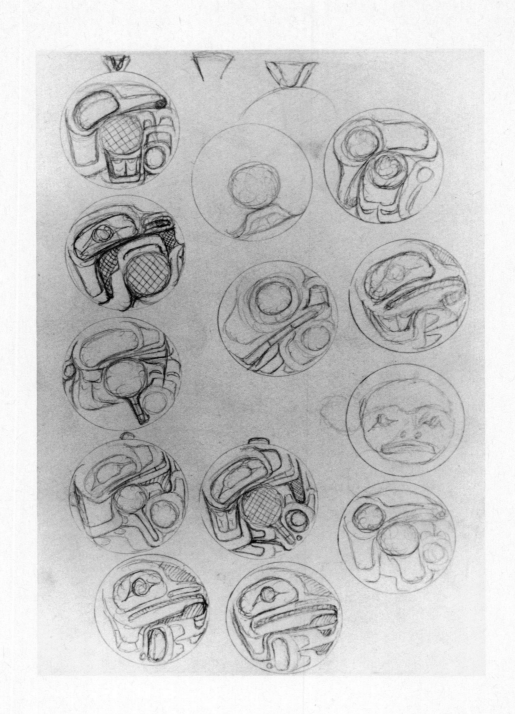

Robert Davidson: Haida Printmaker

Hilary Stewart

University of Washington Press
Seattle

Published by University of Washington Press, 1979, by arrangement with Douglas & McIntyre Ltd., North Vancouver, British Columbia

Library of Congress Cataloging in Publication Data

Stewart, Hilary.
 Robert Davidson, Haida printmaker.
 1. Davidson, Robert, 1946- I. Davidson,
Robert, 1946- II. Title.
NE2237.5.D38A4 1979 769'.92'4 79-4915
ISBN 0-295-95690-9

Acknowledgements

Many people have enriched the contents of this book by contributing information and anecdotes and offering suggestions. For their kind help I would like to thank Florence Davidson, Claude and Sarah Davidson, Susan Davidson, Bill and Mary Gardner, Lia Grundle of Executive Marketing Services, Doreen Jensen, Peggy Martin of Heritage House Gallery, Bud Mintz, Phil Nuyten, Bill Reid, and David Young of the Bent-Box Gallery.

Others have generously provided me with photographs, or allowed me to photograph art works by Robert Davidson. For these courtesies I am indebted to Primrose Adams, Anthony Carter, Agnes Davis, Bill and Mary Gardner, Franz Lindner, Ulli Steltzer, Kenneth and Anne Terriss and May Wolstenholme.

To Susan Davidson, for her help and co-operation in finding photos, providing information, and correcting errors in this work, my very sincere thanks.

I am most grateful to Gordon McKee for making his collection of graphics available to me. Without his generous co-operation and early documentation of Davidson's printed works this book would have been difficult to assemble. His contribution has been significant.

I particularly want to express my warm thanks to Bill Ellis, previously of Canadian Native Prints Ltd., for initiating the idea for this book. His invitation to me to write the catalogue for a small exhibition of Robert Davidson prints that he and the artist were considering led to an exchange of ideas among the three of us, and the result was a complete book on the subject of Davidson's graphic art. As well, I am most appreciative of Bill's expert criticism and guidance through many stages of the manuscript, and for his continued interest in my work.

Robert Davidson spent many hours with me, patiently answering my questions, recalling the early years, discussing his recent works, detailing the background of his prints, correcting the manuscript, and tracking down many of the photographs. His bright, warm smile, his enthusiasm and the charm of his friendly personality have easily rewarded my labours and made the years of working on this book a happy and gratifying experience. Thank you, Robert.

Frontispiece: A page of circle designs from the artist's "ideas book"

Contents

Dogfish design worked out in pen and pencil (#71)

Introduction

In the Northwest Coast Indian languages there was no word for art. Painting, carving, basket weaving and all forms of creativity were part of the complex pattern of living; the embellishment given to a wide range of items — utilitarian to ceremonial — spoke of the wealth, rank, lineage, and spiritual powers of the owners. A man's ability to carve and paint was thought to come from a special vision endowed by a supernatural power, and such dexterity brought a prestigious place in society.

Carving was an important art, but certain items could best be decorated with brush and pigment: dance screens; woven hats and baskets; mats; hide clothing such as dance robes, leggings and aprons, and so on. For the restrained colours of the Northwest Coast palette, pigments were ground from ochre (red); black clay, charcoal or graphite (black); burnt clamshell (white), and blue clay (blue). These were mixed with a binding emulsion of saliva and smoked fish eggs.

With the early traders came the wide distribution of metal tools and the introduction of commercial paints. In addition to providing the means for faster and better carving and the expansion of the artist's palette, trading had another effect on the work of the artist. Ships' officers and crews — and later missionaries, anthropologists and others — were eager to acquire curios and souvenirs from the Indian people. When the natives' supply of trade items began to diminish, they devised new ones. Among these were carvings in argillite, the soft carbonaceous shale (called slate) of a quality found only in the Queen Charlotte Islands. Platters, pipes and a variety of small figures were carved and incised by the Haida purely as salable commodities. Miniature totem poles of wood and of the black argillite were made in quantity; silver dollars, initially of little use to the Indian people, were beaten into bracelets and other jewellery and incised with traditional and other motifs.

A resourceful people, the Haida adapted their traditional skills and knowledge so as to benefit from the new market. Ultimately, changing times and the negative influence of mission and government stemmed their creativity. As the old

craftsmen died, the mainstream of production all but dried up and the principles of the art were forgotten.

In recent years, interest in the cultures of the Northwest Coast Indians has rekindled, and their art has re-emerged in all its forms. Young artists are reaching out to the new opportunities brought about by improved social attitudes towards British Columbia's indigenous peoples and their rich heritage.

Multiple reproduction of native designs on paper through the silkscreen process continues a tradition of two-dimensional art with a contemporary medium. The first Indian artist to reproduce traditional motifs by silkscreening was Ellen Neel, a Kwagiutl living in Alert Bay. In 1948 she printed a variety of crest and other designs on notepaper and even silk ties, but the quality of the work was poor and distribution minimal.

In 1962 Doug Cranmer, also from Alert Bay, silkscreened some of his designs for sale in his Vancouver arts store, The Talking Stick. Two years later Chief Henry Speck (Ozistalis) had ten multicoloured reproductions in an exhibition of his work at the New Design Gallery, Vancouver, and by 1966 Tony Hunt, also Kwagiutl, had three designs published by the Art Gallery of Greater Victoria for sale in its gift shop.

It was the late sixties when Robert Davidson ventured into printmaking, and he was gradually followed by other young artists. In those early years the printing was not good, the paper cheap, and the editions unlimited and unsigned; the finished products often rated meagre framing at best. Bill Ellis, of Canadian Native Prints Ltd., endeavoured to bring Northwest Coast printmaking into the mainstream of Canadian art by encouraging Indian artists to limit the size of their editions and to execute them on high-quality rag papers, signing and numbering each print of the edition. He also published biographical material on the artists, with information concerning each design, and encouraged buyers to use museum-quality framing for permanent preservation of these art works.

Printmaking alone now provides a livelihood for some native artists, though the more versatile combine silkscreen work with carving and jewellery making. Those involved with their traditional cultures often design invitations to a potlatch or other function, where silkscreen prints may also be presented as gifts.

As original prints begin to be marketed in smaller editions and exhibited in art galleries and museums with elaborate opening ceremonies, values are rising even higher; major museums continue to add to their collections, and private collectors are swift to purchase prints by top artists.

But Indian art is not bought only by non-native people. In many villages on the coast, particularly in the Queen Charlotte Islands, Northwest Coast prints of crest and mythical figures are displayed in many homes. Children are once more growing up with a knowledge and appreciation of the great art of their cultures.

Contemporary designs frequently express an artist's Indian-ness, or mark a milestone in his life. Nowhere is this more apparent than in the work of Robert Davidson, now recognized as the most outstanding of the younger generation of artists and an exciting innovator in printmaking.

Just as Eskimo prints have become firmly established as a distinct and distinguished form of Canadian art, so Northwest Coast Indian printmaking has emerged as a link between Indian and non-Indian people. The depiction on paper of traditional crests, of spirit and mythical figures and of legends broadens two worlds: the world of art, and the world of understanding between Canada's diverse cultures. From it can grow appreciation of Northwest Coast Indian art, of the greatness of the old cultures that gave it birth, and of the present generation's perpetuating that powerful art by thoughtful adaptation.

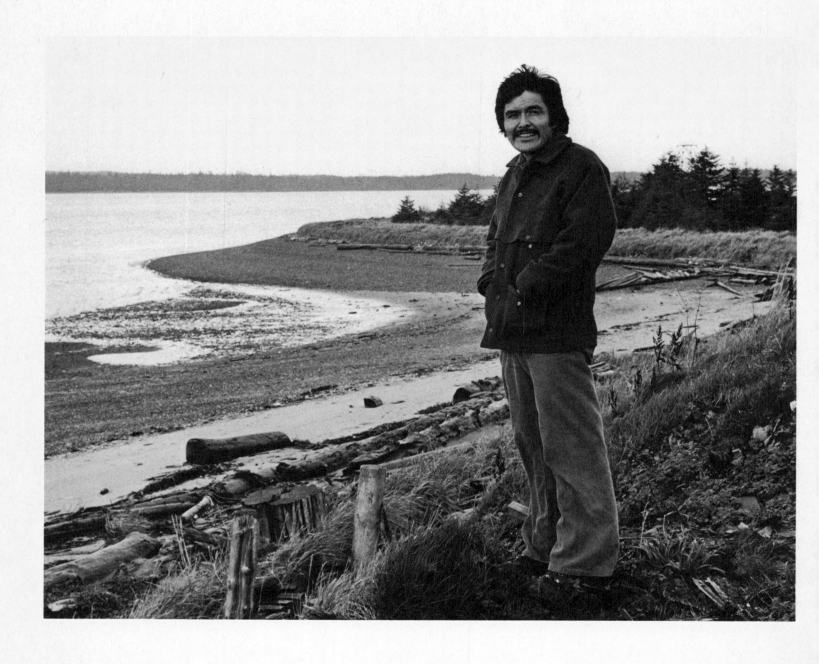

Robert Davidson, Old Masset beach, 1978
Photo Ulli Steltzer

Biography

Claude Davidson's family had lived in Old Masset in the Queen Charlotte Islands for many generations, and when he married a young girl of the Kaigani Haida people, from nearby Alaska, she made her home in his village. Eventually they had a daughter, Arlene. When Vivian Davidson was close to having her second child, she and her husband returned to her village of Hydaburg, and on 4 November 1946 Vivian gave birth to a boy. They named the child Robert after his grandfather, and Charles after his great-grandfather. Four months later they returned by boat to the village of Old Masset, situated three miles from the white township of New Masset. There the family lived with the baby's grandparents, Florence and Robert Davidson, Sr., until a fire destroyed the house.

The Claude Davidson family moved into a small one-room building where a wood stove and Coleman lamp provided heat and light and where well water had to be carried uphill by bucket. Two more children were born to the family: Arnold, who later died, and Reginald.

What young Robert's life lacked in modern facilities was made up for in the warmth and love of family and relatives. For a treat, his mother would often make ice cream in a large wooden ice cream churn, letting Robert and his sister take turns with the handle. After school the battery-powered radio would play the children's stories and dramas that Robert loved to listen to.

Robert's grandmother, Florence Davidson, was like a second mother to him, and he loved visiting her, especially on cold winter mornings when she would make him hot toast dripping with melted fat. He also loved his grandfather, a short man with strong arms and a great deal of wisdom.

Robert Davidson the elder often took his grandson fishing. With young Robert rowing in the bow and the old man in the stern, they would go out with the tide — always *with* the tide — to the halibut fishing grounds. When things were slow, the grandfather would sometimes pretend he had an enormous halibut on his hook, hauling vigorously on the line to excite his grandson. But generally the old man would invoke a halibut, as his people had done for centuries, with beseeching,

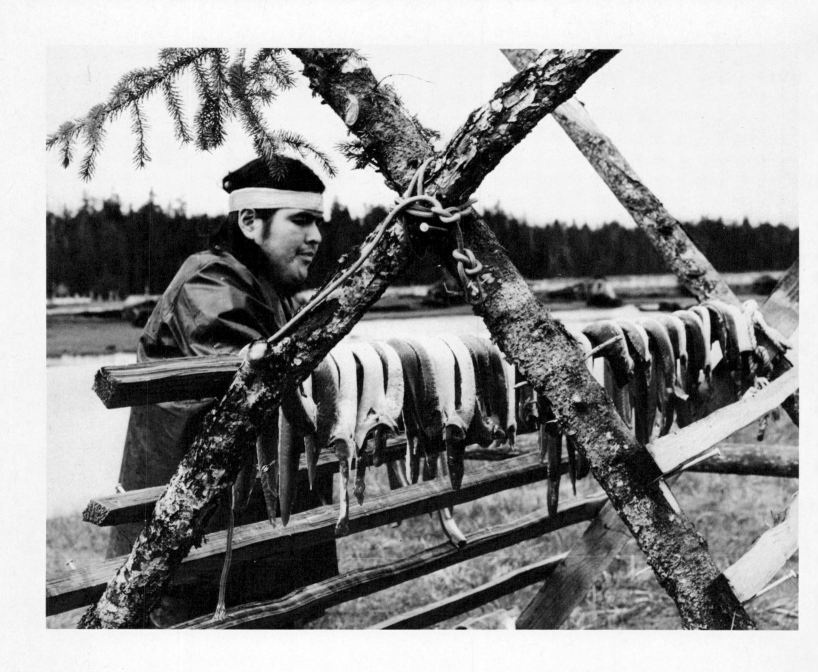

Tending salmon on the drying rack at the Yakoun River
fish camp
Photo Hilary Stewart

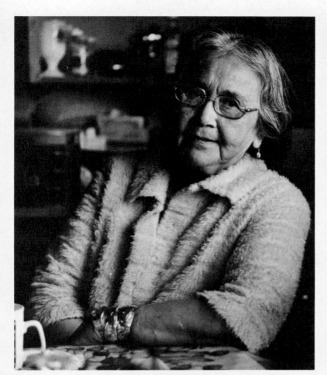
Robert's grandmother Florence Davidson
Photo Ulli Steltzer

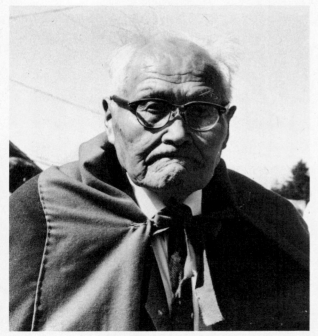
The artist's grandfather, Robert Davidson, Sr., 89 years
Photo Anthony Carter

prayerful words that would ask a fish to take the bait. And when his first catch had been landed and unhooked, he would gently rub the fish with the hook, talking to it in Haida. The two Roberts would fish until the tide turned, then row home with the incoming tide and a boat full of fish. The catch would be cleaned at the water's edge and taken by wheelbarrow up the beach to Florence Davidson's kitchen, where she would cut thin fillets from the large fish and hang them outdoors on a drying rack. As they had done in ancient times, Old Masset people still enjoyed halibut preserved in this way and eaten with eulachon oil. Racks of drying halibut are still to be seen in the village.

The four-grade school Robert attended was at the end of the village and was like most rural schools of its day: a wood frame structure with cedar siding, a row of windows on each side, and a small, square bell-tower. Outside the two schoolrooms, a path through open meadows led to the straggling rows of houses, and a dirt road led to the beach and sea. There was a small playground with the usual swings and teeter-totters, the grass worn away in dirt patches beneath them. Robert adjusted slowly to the routine expectations of school work; he failed Grade 3 and was shattered when his classmates were moved, without him, to the Grade 4 side of his room.

When he was eleven, Robert went to Masset Elementary School in the nearby village of New Masset, where the white people lived. The school was integrated, and there for the first time he came into close contact with white children, for in the 1950s there was little social communication between the Indian and non-Indian people from the two Massets. Because they outnumbered the whites in the school, the Haida students maintained an upper hand and often teased New Masset children mercilessly.

In school Robert loved using a pencil, but though he did a lot of drawing, he always copied pictures from his school books, for in those days there was no thought of showing Indian children the unique art that was their heritage. There were few books on Indian art, and the missions had long ago taught the people to leave behind the old ways. It would have stretched anyone's imagination then to envision the Robert Davidson who in a few years would be using a pencil with easy grace to create freehand designs based on the crests of his

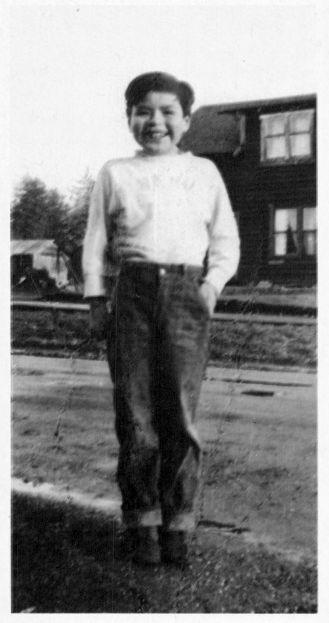

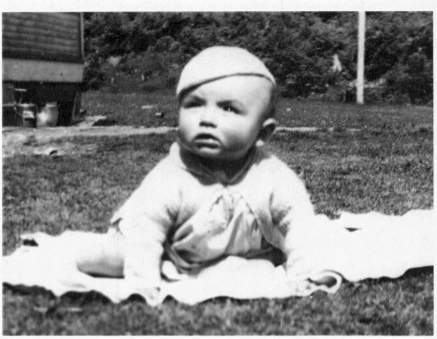

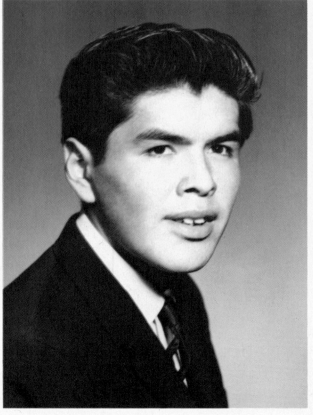

Robert Davidson, Jr. at 6 years old
Photo from the family album of Agnes Davis

Robert at about 6 months old
Photo from the album of Primrose Adams

Graduation, 19 years old
Photo Val Tkatschow, courtesy Bill and Mary Gardner

people, or the traditional animal, bird and spirit creatures of their legends.

Young Robert spent hours alone on the beach whittling simple toys from beach wood. As he learned the feel of wood and how it could be split and carved, he was also developing the understanding of structural shapes that he was to later develop to a high degree. Watching his grandfather carve began to intrigue him. As soon as he returned from school, even at lunch time, he would go to the elder Davidsons' house and stand observing the weathered hands wielding the knife. If the old man put down the knife, his grandson would quickly pick it up and begin to whittle on a stick. Sometimes his grandmother told him not to bother the carver, but Robert senior would interject: "Don't say that; I'm glad he's interested." He knew that the child's great-grandfather, his wife's father, was Chief Charles Edenshaw, a master carver who created great totem poles, silver bracelets, argillite figures and many superb items which had traded and sold in the past. His wife, Florence, was one of two children remaining of Edenshaw's family. At her suggestion, Claude made the boy some tools of his own.

One day the youngster carved a crude totem pole that was little more than a stick with a crosspiece for the wingspan. It was a cliché pole, but his grandfather showed his approval by laughing proudly. He could not know then that one day the boy would singlehandedly carve a magnificent 40-foot pole which would be raised in ceremony in the heart of the village.

In his early teens Robert would visit and chop stove wood for the old people of the village. He felt a strong attachment for them and as he began to learn of the old days from them, of how things used to be, his interest in the past culture of his people grew and became important to him.

Before he was thirteen he had carved his first miniature totem pole in argillite. It was a small piece, 3 inches tall, and he sold it for fifteen dollars, then a lot of money. Robert would work hard on a pole, cutting and engraving it with care, smoothing and polishing it beautifully before showing it to his grandfather. His elder would then recarve it to show him where he went wrong and his father did the same, for the Indian way of teaching is to show how a thing is done, not to talk about it; and the way to learn is to watch and do it, not to read how to do it. Robert visited other elderly carvers to watch

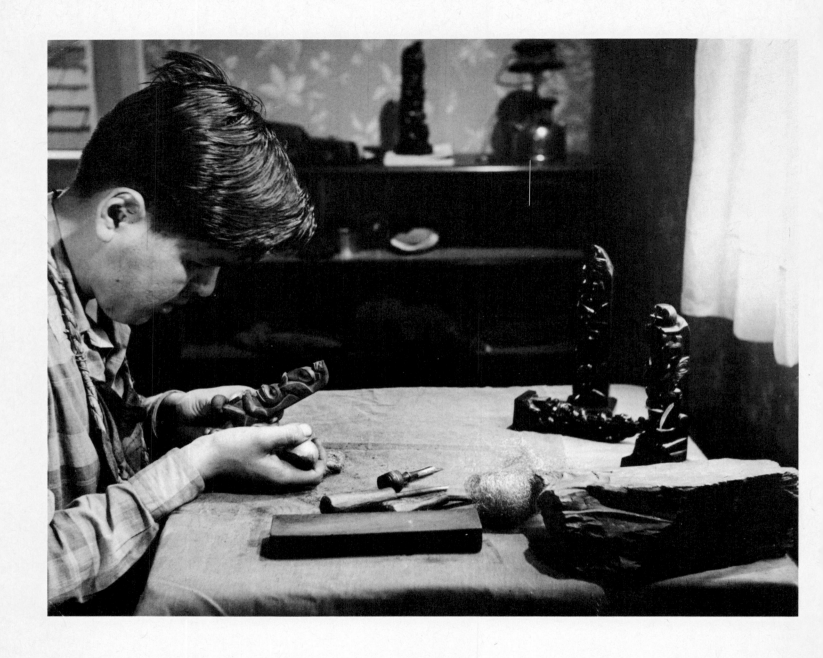

Carving argillite at 16 years old. Note raw material on
right, pre-form at centre and finished poles

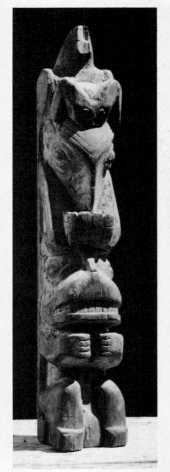

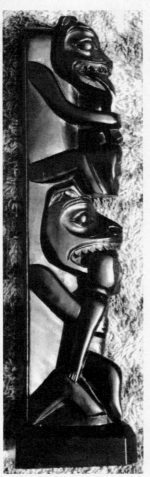

Davidson's first serious pole in wood, made when he was 13, using his grandfather's argillite carving tools. Figures top to bottom are: eagle (beak damaged), frog, raven and bear. Height 27 cm
Photo Hilary Stewart

Argillite pole 19 cm high, designed and carved by the 14-year-old artist, shows his grandfather's influence; the grizzly bear heads do not extend to the edges of the pole
Photo Doug Nealy, courtesy May Woolstenholme

them working, to check on their tools, and gradually his own skill in shaping the soft slate grew. At thirteen he carved his first serious wood pole, 10¾ inches high.

In 1965 young Robert went to Vancouver to attend secondary school, living with Bill and Mary Gardner, relatives of his family's clergyman. In such a huge city a family could not compensate for the loss of the small, warm community where Robert had spent his whole life. His parents knew that he was homesick, and when they came to visit, they brought with them a tape recording of his grandfather singing in Haida, a sound young Robert loved. One Sunday the lonely youth went to the old museum on Hastings Street and there, for the first time, saw some of the carvings of the Haida and other Northwest Coast Indian peoples. He was astounded and fascinated by the art of his people, marvelling at the elaborately carved bowls, ladles, spoons, bentwood boxes, masks and paddles. He had had no idea that such things were once made by the Haida people, since nothing like this remained in his villages. He paid special attention to the fine argillite poles in the glass cases, studying their form and design, and he also took a deep interest in the items carved of wood.

In Grade 12 at Point Grey Secondary School Robert learned the rudiments of silkscreen printing. He recalls printing **Automotive Class** on the back of some of his classmates' overalls — an inauspicious beginning for his later distinguished career as a printmaker, but a beginning nevertheless.

The first time that Robert demonstrated carving was at Eaton's department store, through the initiative of Bill Gardner, an employee there. A short film ran simultaneously; it had been made by the National Film Board of Canada and showed Robert and his grandfather collecting and carving argillite. The year was 1966, and through lack of exposure, native Indian art was not widely appreciated, but awareness of it was growing. The interested — or just curious — gathered around the table to watch the Haida Indian boy with the thick black hair, head bent, carving at the deep grey slate. They asked many questions, and a few placed orders for his argillite work, paying eight dollars an inch.

During a lull Robert became aware of someone quietly watching him as he concentrated on the pole he was carving. Then a deep, soft voice said, "Hi! I'm Bill Reid." The youth had long wanted to meet the famed Haida artist, carver and jewel-

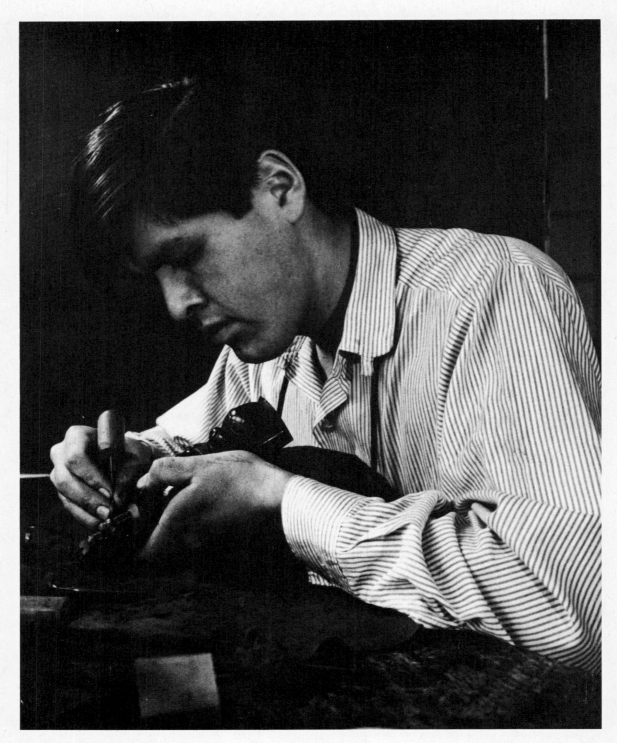

Carving an argillite pole, 19 years old
Photo Bill Reid

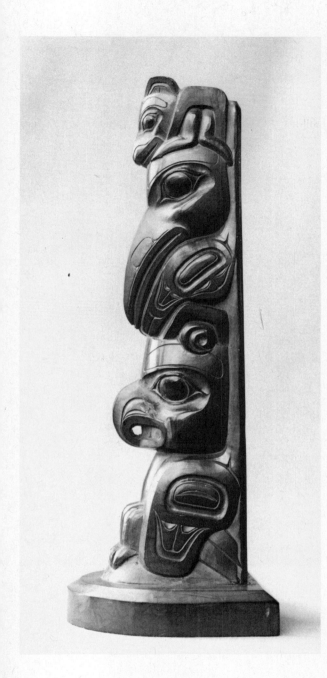

Argillite pole, carved at age 22. Figures from top to
bottom: bear, raven, eagle. Height 18 cm
Photo Hilary Stewart, courtesy Ken and Anne Terriss

ler, but when the moment arrived, he was so overwhelmed
with shyness and so embarrassed by his carving that he
wanted to hide. Bill invited the young carver to his home, but
Robert did not go. They met again later, at the funeral of Rev.
Peter Kelly, the well-known and much-loved minister from the
Queen Charlottes, and this time Robert accompanied Reid
back to his studio on Pender Street.

The two artists had much to discuss. Reid, recognizing
the potential of the nineteen-year-old Haida, talked of helping
Robert enroll in his jewellery-making class at the Vancouver
School of Art. But when no vacancy opened at the school, Reid
took Robert on as an apprentice, teaching him mainly design
and engraving, but including some instruction in copper and
argillite. The Department of Indian Affairs helped to support
the student with a monthly allowance, which he supple-
mented by carving argillite poles for sale.

After Robert had endured seven months of long bus jour-
neys to and from the Pender Street studio each day, Reid
offered to share the studio living quarters with him. The ap-
prentice took his work seriously and spent long hours at the
bench, developing new skills and learning the fundamentals
of two-dimensional design. Earlier, he had met and talked
with the carver Doug Cranmer, who had helped him in under-
standing the art form of the Northwest Coast, but Cranmer
was a Kwagiutl artist and Davidson a Haida, and there were
major differences in their art styles. In studying the classic
style of Haida art, Robert discovered the purity of line and
marvellous elegance in the works of Charles Edenshaw. Al-
though he always refused to lean for recognition on the fame
of his great-grandfather, his work was as much influenced by
that master as it was by Reid.

Robert made his own tools under Reid's guidance, and
together they carved a 6-foot pole of cedar, Reid sculpting one
side of the pole and his apprentice the other. Working on
silver, he had been copying the master's designs for practice,
but the day came when he was to engrave a silver bracelet with
his own design — a grizzly bear motif — which took four days
to create.

In 1967 Robert began studies at the Vancouver School of
Art, in courses that included design, painting, pottery and
sculpture. Characteristically, he studied and worked with
great diligence, always striving for perfection. He met and

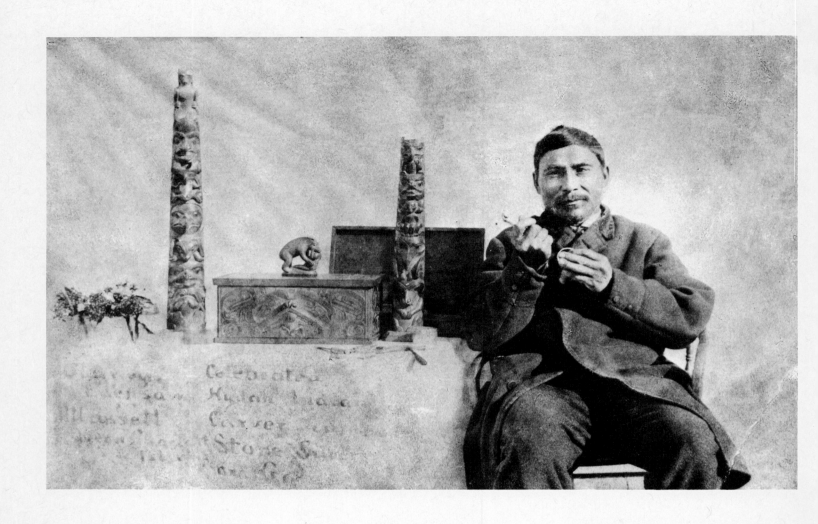

Robert Davidson's great-grandfather Tahayren (Charles
Edenshaw, 1839-1924)
Photo courtesy of National Museum of Canada

talked with non-Indian people having academic and practical knowledge of Northwest Coast art: Wilson Duff, anthropology professor at the University of British Columbia, who shared his thoughts on design; and Bill Holm, professor and curator at the Thomas Burke Memorial Washington State Museum, who discussed the making and using of tools with him.

In 1968 Polly Sargent, the instigator of the reconstructed 'Ksan Indian village near Hazelton, B.C., asked Bill Reid if he would be an instructor at the recently formed school for Indian artists. Reid was unable to take the position but highly recommended his apprentice, Robert Davidson. Only twenty-one years old, Robert went to 'Ksan for six months to teach wood carving. The school did not then have its own building, much less the reputation it has since won, and classes were held in the local fire hall. Robert also taught about ten children who came after school, of whom a couple have become serious carvers.

In 'Ksan at the time was Susan Thomas, who was there to train a curator for the museum in the growing 'Ksan complex. When a red cedar dance screen that Robert had painted got mud on it, Susan offered to clean it, and the two became friends.

With the six months of instruction nearly up, Robert put on a public exhibition of his students' work. He wanted something inexpensive to offer for sale, and, using his limited knowledge of the silkscreen process, he made his first graphic print, a card bearing a frog crest. The motif was copied from an old dance blanket in the Hazelton museum, and as the small frog designs came one by one from the screen, an elated team of helpers pegged them over strings across the room, like washing hung out to dry. The packaged prints were sold as greeting cards.

Robert and Susan, their friendship deepening, returned to Vancouver together. While she continued archaeological work at the Vancouver Centennial Museum, he worked on carving, furthered his interests in silkscreen printing, and took an extension course in jewellery making at the Vancouver School of Art. He was again living at Reid's Pender Street studio, where a spare room had been turned into the silk-screening room. So lacking was he in knowledge of silkscreen equipment, such as drying racks, that he laid his freshly inked

prints on every flat surface — table, chair, floor, and window ledge.

In February of 1969 Robert and Susan were married in Vancouver; a feast and dance were later held by Robert's parents in Old Masset.

An important step that would firmly establish Davidson as a major Haida artist had its beginning at a Pentecostal meeting in Old Masset. He looked around at the faces of all the old people in the room and saw that nothing of their great heritage was left to them. The ancient traditions had fallen from use; there were no more ceremonies, no dancing, drumming or singing of the old songs. The old were just waiting to die.

As a child he had loved the old people, and when the meeting ended, tears filled his eyes as he hugged each one. It saddened him that there was no art in the village, nothing left of the greatness he had come to know about: exquisitely carved masks, bowls, boxes and horn spoons that were locked up in museum cases far from the islands. He felt a deep commitment to those old people, and decided that he would carve a totem pole for them. It would be raised in traditional ceremony with a great potlatch; there would be speeches, gifts and feasting, dancing, drumming and singing. The words of the old songs would return from tucked-away places in the memory of the elders, who would play an important part throughout the proceedings.

Singlemindedly, he set about accomplishing his dream. On the recommendation of Bill Reid, Wilson Duff, and Audrey Hawthorn (then curator of UBC's Museum of Anthropology), Robert was given a grant from the B.C. Cultural Fund to finance the project. After paying all the expenses the carver was left with nothing for himself.

Robert's father spent many days searching for a straight-grained red cedar; but when he had felled one and towed it by boat to the village, it was too slender for the carver's requirements. Claude Davidson then found a second tree of the correct diameter. When Robert saw the 48-foot length of the 4-foot-thick log that he was to carve into a pole, he wondered what he had got himself into.

For a long time there was little interest for the project on which he and his brother Reginald were working. Perhaps the old people remembered the many years when pole raising

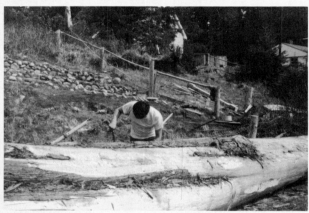

The artist with his parents, Vivian and Claude Davidson, 1969

The start of the 40-foot totem pole: removing bark from the cedar log
Photo from the album of Susan Davidson

22

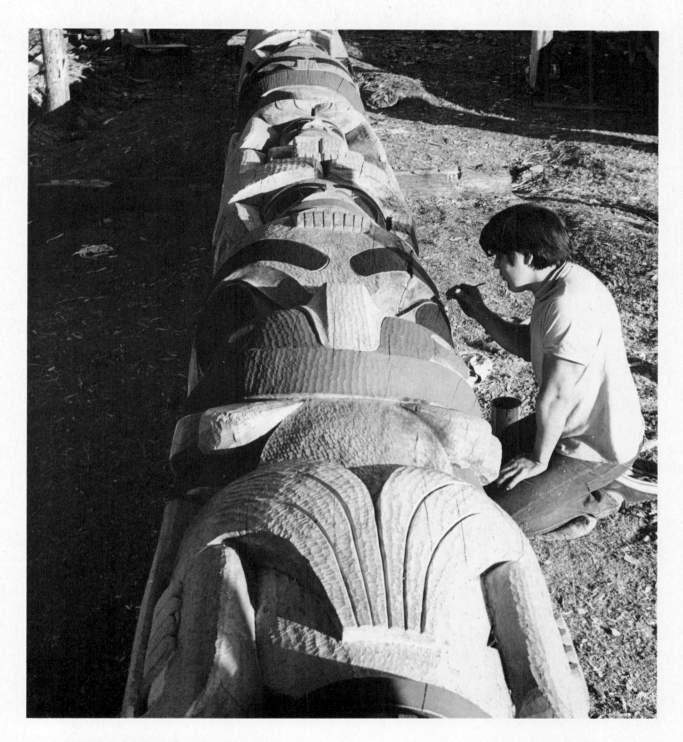

The carver painting red and black features on the
finished pole
Photo Phillip Hobler

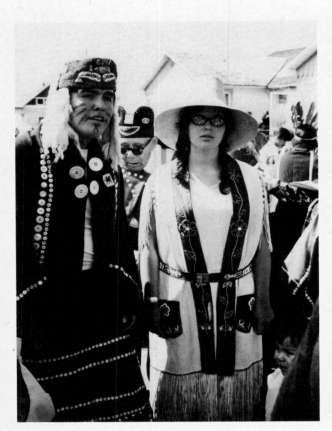

Robert and Susan Davidson at his pole raising ceremony, Old Masset, 1969
Photo Don Wise

and potlatching were banned by law, when the influence of the church made the old traditions unacceptable. Perhaps the young people did not know what it was all about, and perhaps there was skepticism and doubt that raising a pole again could have any meaning for the village. It was not until a few weeks before the event, when the Canadian Broadcasting Corporation and the National Film Board of Canada asked if they could be present to film the ceremony, that the rest of the village began to get excited: the potlatch and pole raising were to be a reality.

Robert was kept busy designing button blanket crests for dancers and others, painting a dance screen, arranging for the pole raising, designing and printing the invitations, and making prints as gifts — all this while still working on the pole. To prepare the feast, his grandmother organized the help of other women, and soon nearly the whole village was involved in the plans to feed six hundred people at the potlatch. Because it is required that gifts be given at a potlatch, Robert adapted a previous design to produce six hundred silkscreen prints, some on paper and some on cloth for a wall hanging to be given to important guests.

Eventually the carefully carved and painted pole, carrying the figures of three grizzly bears surmounted by three watchmen, was raised with ceremony by strong arms hauling on ropes. It rose 40 feet into a blue sky, where it stood tall and straight and proud, proclaiming a new era for all Northwest Coast villages. Pole raising and potlatching had returned to the people of the cedar. The old people danced, drummed, and sang the ancient songs with renewed fervour; old feet softly shuffled, and crested dance blankets flared as they turned, showing the splendour of Frog, Beaver, Killer Whale, and other crests besides Raven and Eagle, the two main crests of all the Haida. The young people watched in wonder and joined in. When the guests went home, elation and a sense of rebirth went with them.

The artist's grandfather, Robert Davidson, Sr., was eighty-nine years old and had been ailing for some time, but he was there to witness and direct the raising of the pole carved by his grandson, the child who once whittled two sticks into a crude little pole. Three weeks later, in September 1969, he died.

When the days of potlatching and feasting ended, Robert

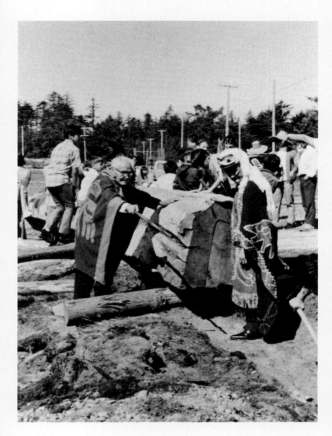

Eighty-nine year old Robert Davidson, Sr. directed the raising of his grandson's pole
Photo Susan Davidson

Davidson, Jr. returned to study at the Vancouver School of Art, concentrating on silkscreen printing and sculpture, with some pottery. He also did silkscreening at home, printing a Haida design of a dogfish in black. His instructor suggested that he try printing in two colours, and the artist did a grizzly bear box design, cutting two screens for it. He bought large sheets of paper and cut them to the required size, but they gave him great trouble in registering the two colours because they were off square.

Although Robert bought books in order to learn more about the craft of silkscreen printing, he did not read them. He found that the Indian way of learning came more naturally to him, and he preferred to visit other artists and watch them work, to talk with them and look at their equipment. He also discussed the process with commercial silkscreen printers. Vancouver's Centennial Museum and Planetarium operated a gift shop, and once when he had gone there to sell his prints, a knowledgeable staff member took him aside and gave him some tips to improve his printing technique. He learned that he should keep his squeegee sharp by turning it every hundred prints, and that he should clean the screen frequently to avoid dust spots. Later he discovered a new type of squeegee made from a synthetic instead of rubber. For a while he even tried making his own screens, but when they fell apart he abandoned them in favour of ready-made screens. Step-by-step he studied, learned and persevered in his own way, and his knowledge and experience and understanding of the silkscreen process grew. And all the time the quality of his prints was improving.

Perhaps the greatest stimulus for the young artist to succeed at making and selling good prints came in a perverse way from a man he never met. A European immigrant had seen a good market in printed reproductions of Northwest Coast art and was selling his own poorly designed, misinformed versions of native crest designs in non-traditional colours. Printed on Japanese rice paper and wood-grain cardboard, his reproductions and postcards — which sold in department stores and gift shops — bore the words *Authentic Indian Design*. These poor imitations angered Robert so much that he determined to make and sell quality prints in the hope of displacing them.

Late in 1969 Robert was commissioned by the National

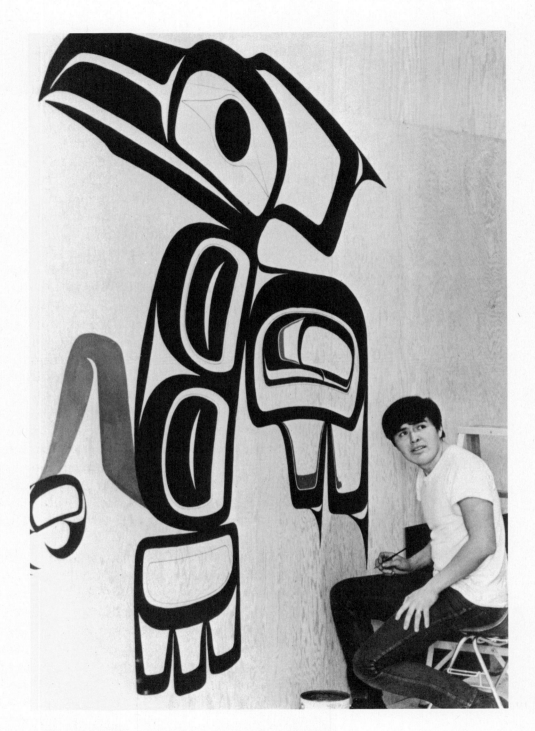

Finishing a raven mural at the entrance of the exhibition
Indian and Eskimo Art of Canada, National Gallery,
Ottawa, 1969
Photo John Evans, courtesy the National Gallery

Gallery in Ottawa to paint a mural at the entrance to the forthcoming exhibition entitled *Indian and Eskimo Art of Canada*. Given two weeks to design and execute the work, he created Raven, Eagle, Hawk and Thunderbird in red and black on the four floor-to-ceiling panels. With assistance from another painter working on the exhibition, the work was completed within the deadline.

In the same year Audrey Hawthorn was asked by Mayor Drapeau of Montreal to display some of the museum's magnificent collection of Northwest Coast art at the *Man and His World* exhibition. The following year Hawthorn invited Robert to demonstrate wood carving for the continuing exhibition, and he accepted. Since Bill Reid was at that time living and working in Montreal, he also took part in demonstrating carving; Robert worked five days a week, Reid filled in for the other two days. Robert completed a 10-foot pole, which he presented to the city. As well, he carved four masks and a rattle (the latter was stolen from the display), and offered for sale silkscreen prints of a beaver. There was a growing curiosity about the unusual form of design, and several prints were sold.

Later that summer of 1970 Robert was sponsored by the World Council of Craftsmen to be the Canadian delegate at their conference in Dublin, Ireland. Great interest was shown as he demonstrated carving on a 10-foot pole that he had begun in Canada. When finished, the pole was given to the city and later installed in the Dublin zoo.

By now Robert's prints were attracting the special enthusiasm of Peggy Martin, manager of the Vancouver Centennial Museum and Planetarium gift shop. She had been with the Vancouver Art Gallery during the magnificent *Arts of the Raven* exhibition of Northwest Coast art, and as an art historian who recognized the depth and quality of the tradition, she welcomed the prints as an innovative form. For a long time, uninitiated buyers showed a reluctance to accept silkscreen designs as "genuine Indian art," but Peggy Martin kept Robert's prints on display and encouraged purchasers by helping them to understand the more stylized or abstract designs.

Other dealers, including Lia (McGookin) Grundle of Tempo, Bill Ellis of Canadian Native Prints, and Mrs. Alistair Bell at the Vancouver Art Galley gift shop, encouraged the

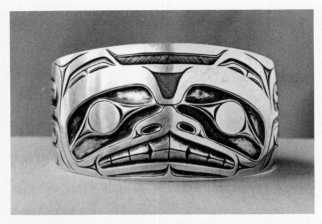

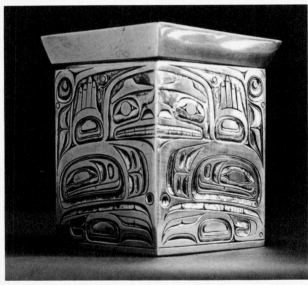

Silver bracelet with Beaver design
Photo Hilary Stewart, courtesy Anne Terriss

Miniature silver box made at the Pender Street studio
Photo Hilary Stewart, courtesy Susan Davidson

artist by buying his signed and numbered prints. When Bill Reid published his first limited edition, his agent, Bill Ellis, printed a colour brochure illustrating both Reid's and Davidson's prints under the banner *Original Prints by Living Northwest Coast Indian Artists*. Gradually, a small core of alert collectors began buying signed Northwest Coast silkscreen prints, and before long numerous other Indian artists on the West Coast and elsewhere in Canada were marketing prints.

The first one-man show for a Northwest Coast Indian artist was the exhibition arranged for Robert Davidson in 1971 by Peggy Martin at the Vancouver Centennial Museum and Planetarium. The opening night of the exhibition was well attended; the masks, argillite carvings, jewellery, prints and other works on display clearly demonstrated that Davidson was a major new artist. Buyers quickly claimed almost all the items of silver he had made for sale, and the prints were received well both at the exhibition and in the shop during the ensuing weeks.

Meanwhile, the Davidsons had bought a house and a few acres in the country near Whonnock, 40 miles from the city, where Robert planned to build a separate studio. To notify his friends and clients of his house moving, Robert printed and mailed cards with the change of address. The cover showed a flying raven bearing a house in its beak.

That same year the B.C. Provincial Museum in Victoria mounted a large exhibition entitled *The Legacy*. For the first time, significant art works of contemporary B.C. Indian artists were assembled in a striking exhibition, proving the strength and vitality of art forms popularly thought to be "lost" or "dead." Intricate baskets of inner cedar bark, decorated with dried grasses and cherry bark, proved that deft fingers still knew how to prepare and work the natural materials; beautifully soft blankets woven on a two-bar Salish loom demonstrated that women of the south coast continued to spin, dye and weave in wool. Masks, dance capes and aprons, boxes, bowls, ladles and spoons showed that the lavish paraphernalia of feasting and ceremony were not things of the past. Exotic jewellery in silver and gold, an Indian art form only a century old, proclaimed without doubt that native artists were building upon old traditions with new materials. In this exhibition the skill and versatility of Robert Davidson was well represented by a dogfish rattle, two silver spoons, an

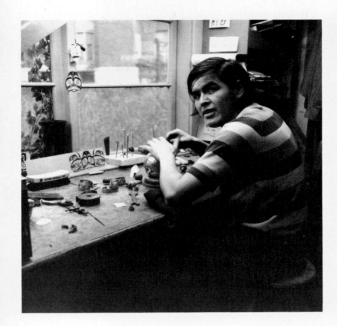

Engraving a silver bracelet at the Pender Street studio
Photo Ken Spotswood

argillite bowl and a 2-inch wide silver bracelet depicting the blind halibut fisherman and Raven with a broken beak. Regrettably, the latter was stolen from the exhibit.

While Robert continued to work on carving and jewellery commissions, he also concentrated on silkscreen printing, challenging himself to cut and pull prints to the highest possible standard. Lines had to be perfect in form and razor sharp and the registration of red and black had to be absolutely exact. He preferred mixing his own red so as to achieve a colour close to the red used by the old masters of Haida art, and he studied the colour on old painted boxes and chests to define the shade he wanted. He was dissatisfied with the starkness of white paper and looked for a light cedar colour.

Robert was responsible for encouraging other native artists to begin silkscreen printing, and his high quality of work set a standard for them. Haida artist Gerry Marks and Norman Tait of the Nishga entered into printmaking, and Larry Rosso and others soon followed. Robert's influence on young Indian artists was far-reaching. As well as offering advice and suggestions, he encouraged others indirectly by his obvious success in the market, and he made it acceptable, by his example, for native people to visit universities and museums to seek knowledge from academics. With a strong sense of pride in himself and his Haida background, he researched the collections and learned from the masterworks of the past.

Although several Northwest Coast Indian artists were now selling prints, Robert was one of very few doing their own printing, the others preferring to leave such skilled work to printers. But commercial printers seldom had the time to produce such high quality work as the Haida artist working in his own studio did, for he would pay attention to every detail of the process, checking each print as it was pulled, looking for dust spots and other flaws. After careful proofing, Robert usually discarded five per cent of the printing, but to have an edition of perfect prints suitable for signing, he might destroy as many as twenty per cent. Once he found two minute flaws in an edition of seventy-five prints and destroyed them all. Rejects from the edition were always either burned or the backs used for proofing.

For cards and small prints the artist would use off-cuts of paper from larger designs, and the number of the edition would depend on the paper on hand. But it would also de-

pend on his mood. If there were problems, if he became bored with the work, or frustrated, he would limit the edition drastically; on the other hand, if the printing was going well and he was enjoying it, he would continue. He liked to do an edition of prints all in one day, sometimes staying with a two-colour print six to seven hours straight. If there were someone working with him to proof the prints, then he could print up to 350 in one day.

The reputation of Robert Davidson, artist and carver, spread beyond North America, and in 1972 he was invited to Berne, Switzerland, to demonstrate carving for a major department store. He took with him a number of silkscreen prints of the beaver design (#22) and sold them to people fascinated by this unusual art by a Canadian Indian. During his visit to Europe, Robert visited museums and private collections of Northwest Coast art in Switzerland and Germany, to further study Haida art.

Back in Whonnock, Robert was joined by Bill Reid in building additional studio space to accommodate large sculptures such as the 12-foot pole that art patron Walter Koerner had recently commissioned him to do. Reid designed the pole, then he and Davidson carved it together.

As well as successfully marketing his prints, Robert had established a tradition of sending his many friends and clients a hand-screened Christmas card, always in Haida design, and sometimes having a message concealed in the design. The use of printed cards to mark major events in his life was also a well-established pattern, and in 1973 the birth of his first child, a girl, inspired two highly expressive prints (#31 and #32).

The British Columbia Provincial Museum, in Victoria, needed a suitable place for the native carvers it employed, where they could work and store their tools. Adjacent to the museum a Haida plank house was built by Indian people skilled in the use of aboriginal-style adzes, and Robert Davidson was among those chosen to hand-adze the massive roof beams. The work was carried on outside the museum building through the summer of 1974: the sounds of adze on cedar filled the air, and wood chips littered the terrace as the activity became a constant source of interest to both tourist and resident. In his spare time Robert took the opportunity to study more closely the Haida art pieces in the museum's collection.

The following two years, 1975 and 1976, saw continued commissions coming to him for masks and small carvings as well as silver and gold jewellery and silkscreen prints. Because of his enquiring mind the artist was always probing and experimenting: trying out new ideas, new shapes and new concepts in design. Having mastered the traditional he was able to break with tradition, and he took great satisfaction in manipulating the art forms in new ways.

During these years Robert concentrated on print design and made great strides. Bill Reid had become an innovator in three-dimensional art by setting himself the most rigorous standards of classic Haida design in wood, argillite, silver and gold. Although Reid had a few prints on the market, Davidson saw printmaking as an undeveloped area of native art that he could take to a higher level. He explored ways of introducing subtleties into many of his designs, experimented with colour combinations in a series of Moon prints, and challenged himself with the difficulties of designing within a circle. By now his style of print design was unmistakable.

In the spring of 1976 his wife gave birth to a son, Benjamin, and the artist marked the occasion with a special card design that embraced the whole family (#56). Also in the spring of that year he was commissioned by the Canadian Broadcasting Corporation to create a carved cedar screen for the B.C. Director's executive suite in a lavish new Vancouver radio and television complex. Robert had observed the activities within the television studios and had perceived, through the filming of his pole-raising ceremonies, how the camera's interpretation of the events was a reflection, not an exact image, of reality. He envisioned a design of two circular motifs, 52 inches in diameter, which appeared to be exact mirror reflections, but were not; five elements in one circle were subtly different from their counterparts in the other, symbolizing the difference between reality and interpretation.

Many of Robert's works began to show signs of an artist maturing intellectually as well as technically. His designs went beyond graphic representation as he delved into imagery, struggled to understand his own consciousness, and sought to portray his thoughts and feelings through design. Robert discovered philosophizing and enjoyed discussing abstract ideas. He now defined and elaborated his concepts in words, and his words helped inspire new refinements, such

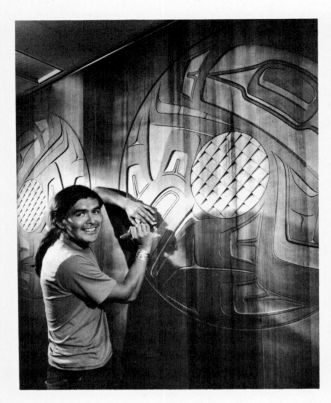

The artist and carved panels at the Canadian
Broadcasting Corporation complex
Photo Franz Lindner

as those in the carved screen. Similar thought processes entered into his prints.

Robert's proficiency with circular motifs came to the fore when, in 1976, he was commissioned by the North West Cultural Society to design a Haida coin in the Indian Heritage Series, a series of five one-dollar coins representing the five major tribes of the Northwest Coast. One side of the coin held a portrait of Charles Edenshaw; on the other Robert used a sea monster motif from a pendant he had previously designed. The coins, struck in nickel, silver and gold, are now prized collectors' items.

October of 1976 saw Davidson again return to the Queen Charlotte Islands. Bill Reid was carving a 40-foot frontal pole for the new Skidegate Band Council offices, which had been designed by Rudy Kovach in the style of an early Haida house. Reid accepted his former apprentice's offer of help and asked him to design and carve the raven wings, the killer whale fin, and other flat areas. For two weeks before returning to the mainland and his next project, Robert chiselled and gouged flowing lines and elegant shapes into the cedar crest figures.

The Federal Government department Parks Canada had — appropriately — commissioned him to design and execute a monument as a memorial to Charles Edenshaw, who had lived and died in Old Masset. He chose to carve and paint a design on a house front. The traditional style plank house would be part of an already planned three-building complex — also designed by Rudy Kovach — to house a recreation centre for the village.

Feeling a need to be away from the domestic and rural environment of Whonnock, Robert moved back to Vancouver in January of 1977 and began to prepare for the two-year project, his most significant to date. He researched and studied works carved by his great-grandfather, attended meetings with the project organizers, submitted designs, advised on materials and attended to many details of the major task ahead of him.

In May Robert went to Old Masset to start the memorial. He made complete scale drawings of the design that was to fill the house front — 35 feet wide and 11.5 feet high at the centre peak — and then enlarged them to full-size drawings. His young brother Reginald and Gerry Marks from the village became his assistants. Together with twenty volunteers they

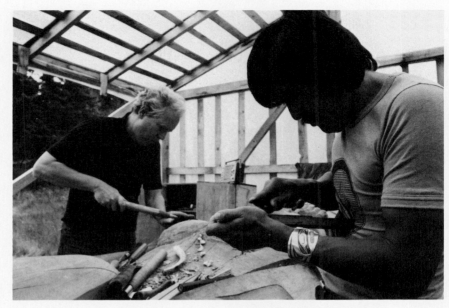

Working with Bill Reid on his pole, Skidegate, 1977
Photo Hilary Stewart

built a carving shed, working ten and twelve hours a day to finish it in three weeks. In the tradition of naming houses, the building was called "Shark House" at the suggestion of Robert's grandmother, whose family position and knowledge of the old ways always had his respect.

For the house front motif the artist had adapted a frog design originally carved by Edenshaw on a chief's seat, which is now in the B.C. Provincial Museum. Huge planks that would form the front of the house were laid across saw-horses, and Robert and his apprentices spent the summer working on the project, meeting and solving the many difficulties and problems that arose.

After working five days a week in Old Masset, Robert often packed his tools and drove the 75 miles south to Skidegate to spend weekends continuing his work on Reid's pole. They worked quietly together while classical music played softly on a radio in the half-shed: two master carvers sharing more than the cedar log that lay across the trestles.

The Edenshaw Memorial, carved and painted, was complete by fall. In November Robert followed another tradition: that of publicly making payment to those who had participated in the project and the potlatch. He called certain people to the carving shed and paid them according to their contribution — help in building the carving shed, unloading the planks from the truck, singing or speechmaking at the feast, and so

33

on. As payment was given, the reason was stated, and the assembled crowd witnessed cancellation of the indebtedness. Davidson's total outlay was $1,500. The village chief was given money in respectful acknowledgement of his rank and presence.

Robert had earlier become involved in the setting up of the Northwest Coast Indian Artists Guild — a group of eleven artists whose aim was to promote and encourage national and international recognition of Northwest Coast Indian art while maintaining high quality in design, craftsmanship and materials. In October the Guild held its first annual exhibition at the Vancouver Art Gallery, showing three Davidson prints (#62, #63, and #65) which sold within minutes. That year also saw five of his prints reproduced as art cards by Canadian Native Prints, the company that also published Bill Reid's prints and art cards.

In the first part of 1978 Robert continued to make silkscreen prints, and worked on five carved pieces for a forthcoming exhibition, but by early summer he was back at his village to continue working on the Haida house. Two pairs of carved house posts were required for the interior, and he first made scale models of these, one incorporating a raven, the other an eagle. Then he set out to find and cut suitable trees. Through his persistence, Davidson acquired funding for an apprenticeship program that would enable eight young artists of the village to improve their carving and design skills. Maturing as a person as well as an artist, he now had the self-confidence to supervise and guide those young apprentices, to criticize their work, and to encourage them. Throughout the summer he gave talks and slide shows on the highly developed art form of the great Haida traditions.

Because he was in the Charlottes, Robert was unable to attend the opening of the second annual exhibition of the Northwest Coast Indian Artists Guild, which included one of his prints (#70).

On 4 November 1978 an official ceremony was held in Old Masset to dedicate the memorial to Charles Edenshaw and to raise the house posts. Because of its federal funding, the occasion was marked in official government style, but that night the village rejoiced with a Haida-style feast and celebration in the community house. It had been just over nine years since Robert's pole had been raised in Old Masset.

Also in November a lavish poster bearing a black-and-red box design on a gold background was created to promote the opening, at the Bent-Box Gallery in Vancouver, of a one-man exhibition by Robert Davidson. The show comprised both old and new works and included many out-of-print graphics. A small and crudely carved wooden pole — his first, carved when he was thirteen — stood beside new works priced at several thousands of dollars. A print that had been brought out in 1972, now framed, was priced at nearly eighty times its original value.

Ten years of printmaking have given Robert Davidson more than merely a continuing income; more than skills, knowledge, recognition and a way of marking the milestones of his adult life. They have helped him get in touch with and gain a better understanding of himself. And they have helped him reach out to others in a way that carving and jewellery making could not have done, for his designs, which often reflected his thoughts and actions, were sent as cards to hundreds of people. As well, they were affordable as prints to many who could not commission him to carve a pole or a silver bracelet.

Seen chronologically, the seventy-five designs, their styles and the events and circumstances involved in their creation, mirror the development of the artist and the man. The two-dimensional designs trace his progress from the first copied motif in one colour, through his two-colour work and ex-perimentations, to his innovation and perfection of technique. They reflect his growth from a young student with little ex-perience of life outside his village to a man broadened as world traveller, researcher, exhibitor, carver, jeweller, instruc-tor and organizer.

His prints also weave his warm personal story into the colourful fabric of the contemporary art of the Northwest Coast Indians. They document the early years of Robert Davidson, who will take his place beside the great Haida artists whose names are as legendary as the Raven and the Eagle.

Rough design for *Beaver* (#45)

Initial pen sketch, later modified in pencil, became the
basis for *Sea Ghost* (#40)

The Prints

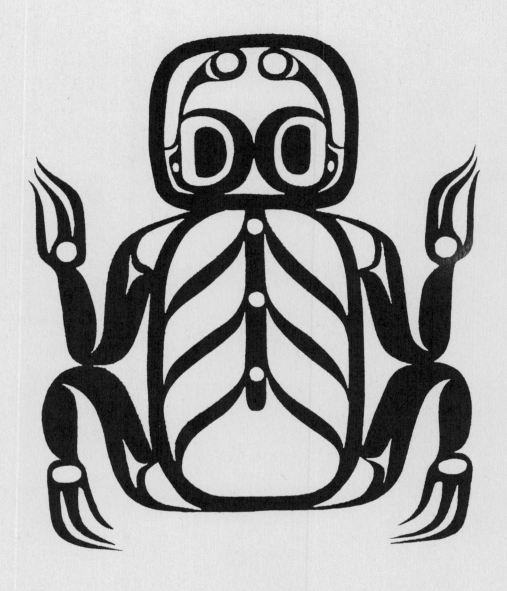

1 / Frog

650 printed / black on cream; red on cream; black on brown; red on
brown 13 x 17 cm / 1968

While a carving instructor at the Gitenmaax school of Northwest Coast
Indian Art, at 'Ksan, Robert Davidson printed his first graphic design.
Not having worked previously in the two-dimensional medium of
silkscreen printing, he copied a frog motif from an old dance blanket in
the Hazelton museum.

With the help of his students, Robert printed 650 cards bearing the
simple frog design; they sold singly or by the dozen at an exhibition of
the students' work. The cards were printed in red or black on both a
cream and a brown background. The combination of red on brown,
together with the shortcomings of the design, resulted in a visual
disaster that gave no hint of the young artist's potential as a great
designer and printmaker, yet time has given these cards a coveted
status among collectors of Robert Davidson graphics.

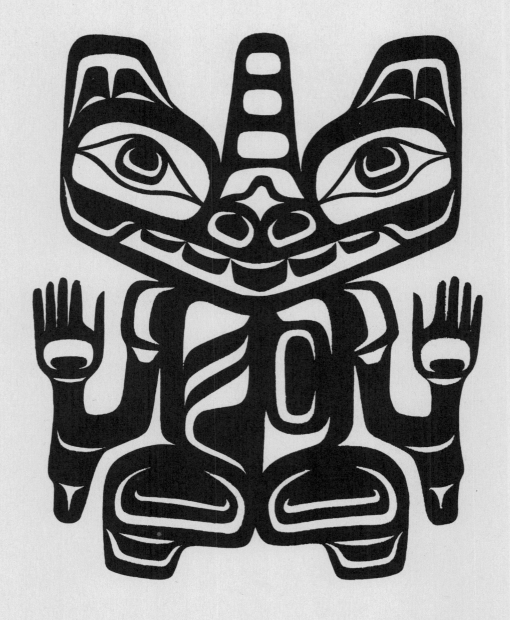

The second print of the artist's career was also made at 'Ksan. For the design Robert again copied a dance blanket motif — this one a Sea Bear photographed in *Art of the Northwest Coast Indians* by Bruce Inverarity.

Although Davidson copied the basic design of the Sea Bear, he enhanced it expertly by correcting the misproportioned lines and irregular shapes, thus giving it a tighter, cleaner look.

A comparison of the original Sea Bear with that of Davidson's card reveals the artist's understanding of and regard for the Haida art tradition, and this respect endured throughout the printmaking years ahead.

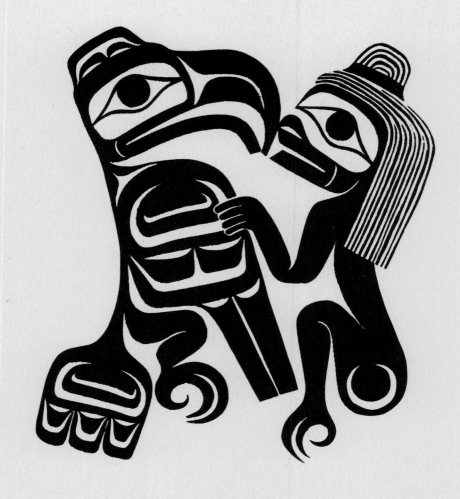

A special card to announce the marriage of Robert Davidson to Susan Thomas, whom the artist met while instructing in 'Ksan, was the first of what became a series of personal cards marking events in Robert's life. The marriage announcement card was also the first design that he created entirely himself so as to convey a message visually.

All Haida people are of either the Eagle or the Raven moiety, so Davidson portrayed himself on the card according to his lineage, that of the Eagle. Tradition dictates that a person of one moiety must marry someone from the other, but since his wife was not Indian, the artist depicted her simply as a woman, and showed the two facing figures in an embrace.

The card's only words were: Robert and Susan Davidson 18 February 1969. The friends who read this message had to discern its meaning by examining the design, thereby experiencing for the first time a device of many future cards from Robert — a subtle symbolism that invites the recipient to discover the design's hidden meanings.

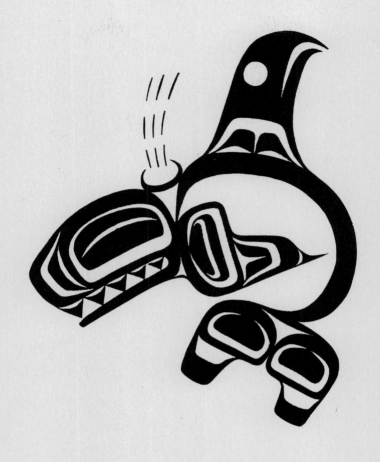

4 / Killer Whale

75 printed / 10 x 13 cm / 1969

To honour the marriage of Robert and Susan Davidson, which took place in Vancouver, the groom's parents gave a celebration dance in the village of Masset, where their children had grown up and where the family still lived. It was a joyous and lavish affair, and a great many people brought gifts for the young couple. Robert and Susan acknowledged this kindness with a celebrative card bearing a leaping, spouting Killer Whale and the words "Thank you."

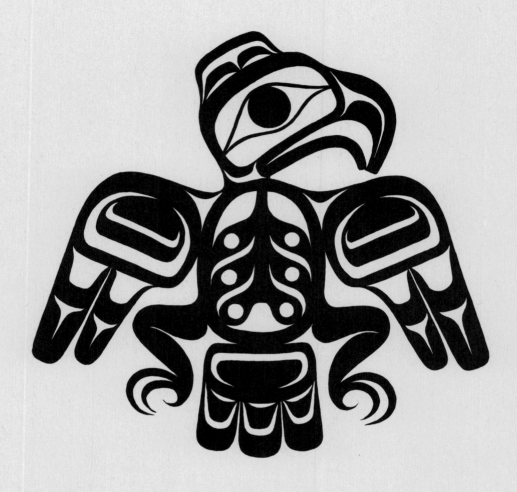

5 / Eagle
20 printed / 36 x 46 cm / 1969

Davidson was commissioned by the University of British Columbia to illustrate the cover of a brochure describing the 1969 program of the Department of Continuing Education. He painted an Eagle motif in black, and the design was enlarged photographically for reproduction.

From the enlargement the artist cut a screen and pulled twenty prints on different coloured backgrounds to evaluate the varied effects. He found that the classic art did not benefit from most tinted backgrounds except for a beige that suggested the warmth of light red cedar.

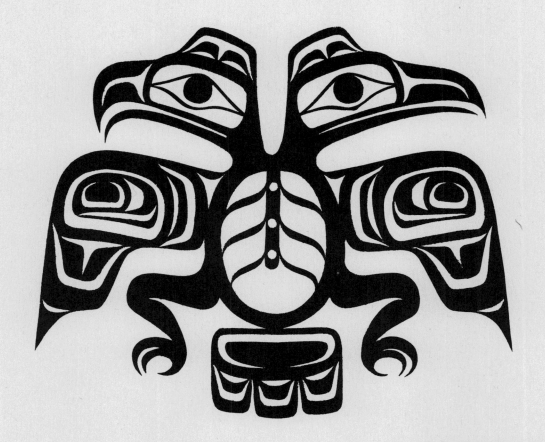

6 / Pole-raising Potlatch Invitation
600 cards / 16 x 13 cm / 1969

6a, 6b / Pole-raising Potlatch Gift
175 on burlap; 425 on paper / 36 x 43 cm / 1969

Preparations for the great potlatch and pole raising of 1969 in Old Masset were in full swing. People were sewing new button blankets to Robert Davidson's designs; Susan Davidson was stitching banners as gifts; quantities of food were being prepared; the Canadian Broadcasting Corporation and the National Film Board had made arrangements for filming the event. Though the painting of the pole was not yet completed, and many other tasks remained to be done, Davidson undertook to design and print invitations.

The artist reworked a previous eagle design (#5) to depict the unity of the two main crests of Masset: the Eagle's head was joined by a Raven's head on the same body.

Six hundred invitations were required, and because of the wording needed inside, they had to be printed twice: 1,200 pulls, plus 600 for the gift prints. Davidson appealed for extra help and was joined by four volunteers, members of Knut Fladmark's archaeology crew, who were working on a dig nearby. Robert, Susan and their enthusiastic aides

had soon turned the basement of the vicarage into a high-production line, printing one side of one card every five seconds.

The wording inside the card was by Chief Weah:

The Village of Old Masset
invites you to attend a
Totem Pole Raising
by the Eagle and Raven Clans.
We would be proud to have you
honour us with your presence,
on 22 August 1969

In addition to the invitation cards, 600 more were printed as gifts to be distributed to the guests. Of these, 175 were reproduced on burlap and made into hanging banners, for the more important guests, and 425 were printed on paper.

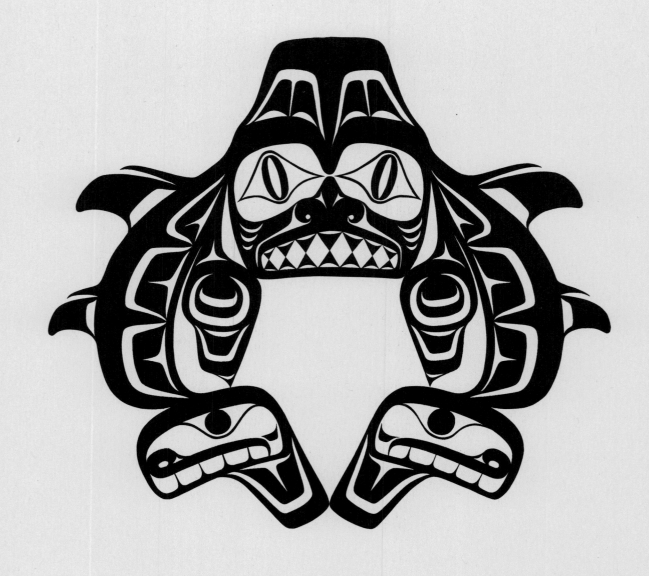

7 / Dogfish

225 printed / red on grey 36 x 46 cm; black on buff 46 x 51 cm / 1969

Printed in red on grey paper and black on buff, this split Dogfish marks a significant point in Robert Davidson's career: it is the first reproduction he made to be marketed. In taking it from store to store he found that most buyers were not familiar with Northwest Coast Indian art and were reluctant to purchase; although he sold several copies, he gave most away to friends.

Dogfish is shown as a vertical split figure; both sides of the body are visible at the same time, as though each were being viewed in profile. Each side displays two dorsal spines and a pectoral fin; small faces decorate the asymmetrical tail flukes beneath.

44

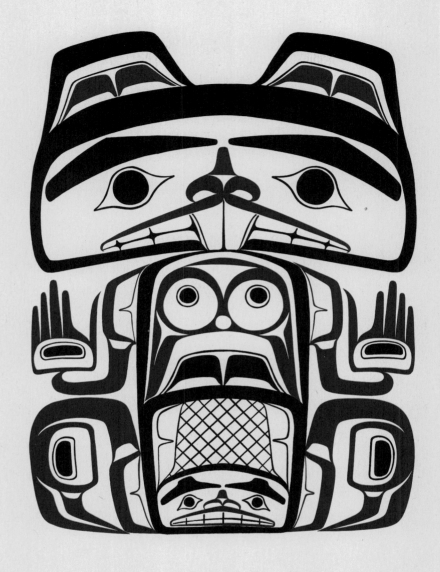

8 / Beaver
300 printed / 33 x 43 cm / 1969

The two large incisor teeth and the cross-hatched tail, turned up into the body, identify the creature in this well-balanced design as Beaver. The simple lines and the large size of the head offset the complexity of body and legs in a satisfying way.

Inspiration for the print came from a Haida design, printed on leather dance leggings. Robert found the illustration in Franz Boas's *Primitive Art*, and reworked the motif to conform to a rectangular shape.

Still showing his work at one store after another, Robert found that interest in his graphics was increasing, but the Beaver designs that he gave away still outnumbered those he sold.

The artist's grandfather, Robert Davidson, Sr., died in September 1969, and a memorial feast was held for him the following year. Being of the Eagle moiety, he was entitled to the Beaver crest, and so the younger Davidson made a second run of ninety prints of this design to be given away at the feast.

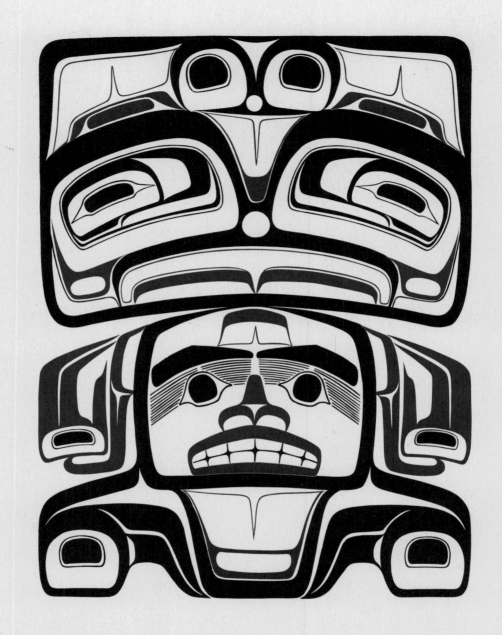

9 / Sea Bear Box Front

75 printed / 50 x 65 cm / 1969

In these early years, Davidson was immersing himself in traditional Haida art, and became particularly interested in the painted designs of the early bentwood boxes. On a visit to Old Masset he discovered one of these in the home of a resident, and traded a gold bracelet for it. However, when someone else claimed rightful ownership of the box, Davidson was obliged to pay again with another bracelet.

These storage boxes and chests, made by steam-bending a single cedar plank to which base and lid were added, were unique to the Northwest Coast. They were frequently painted on the back and front, and generally on the ends also; in very elaborate chests the design was both painted and carved.

For this two-part representation of the Sea Bear the artist put

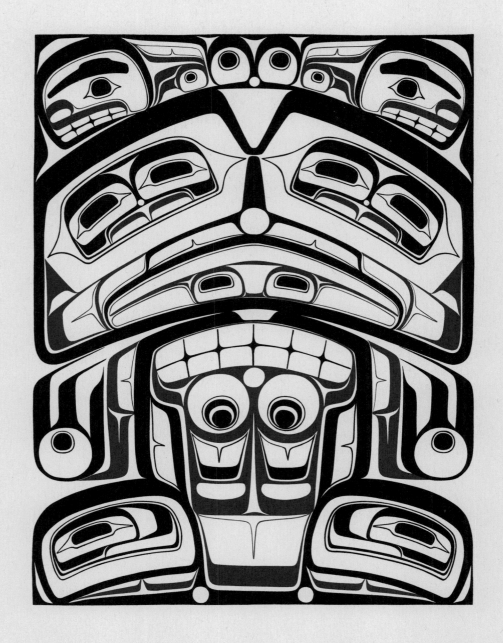

10 / Sea Bear Box Back
75 printed / 50 x 65 cm / 1969

together several elements from well-designed boxes, creating his own portrayal. The box front design includes the stylized features of the mythical Sea Bear; the back represents a bear with four flippers instead of paws.

In each graphic the head is seen in the upper half, with the ears in the corners; the central part is the body and carries a face for decora-tion; the hind legs occupy the lower corners; the front legs, with paws or flippers, are at each side.

The box designs were Robert's first in two colours, the traditional black and red, and for a novice he succeeded remarkably well — aesthetically if not commercially, since he was still giving away more than he sold in spite of the modest price.

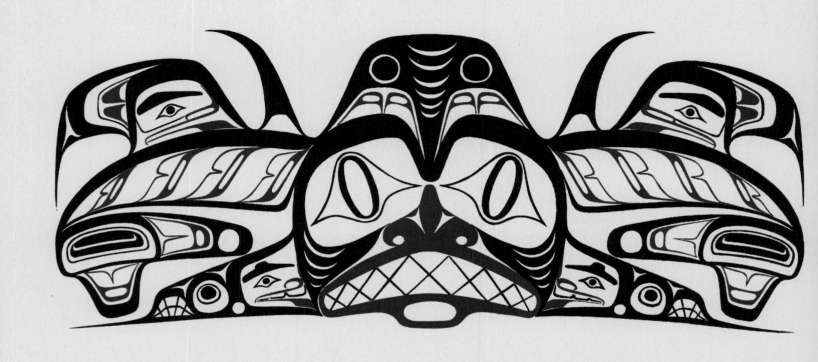

11 / Dogfish
250 printed / 22 x 10 cm / 1969

Christmas 1969 saw the start of Davidson's annual practice of designing and printing his own cards of greeting which he sent to friends, customers and associates.

For the first card he chose the Dogfish, a crest motif he favoured, as had many artists before him. Like the Dogfish of his first market print, this one is a symmetrical image, as were many traditional Haida designs. The split Dogfish is visualized as being horizontal rather than vertical as in print #19. It has the dogfish's characteristic domed head, gill slits and pointed teeth, together with fins and spines. The asymmetrical tail curves around from the body, which is identifiable by its pattern of ribs.

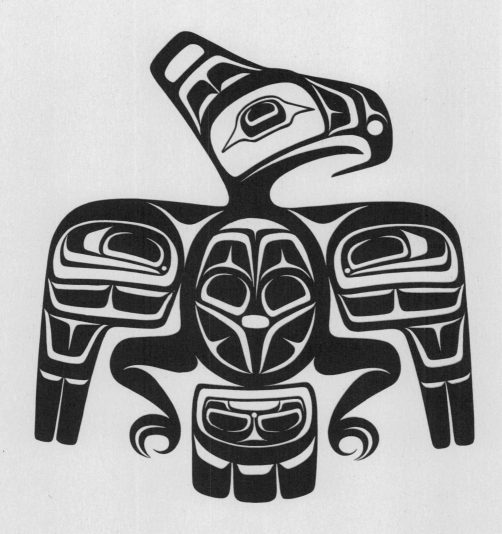

12 / Thunderbird
200 printed / 36 x 46 cm / 1970

One of the many preparations for the 1969 potlatch and pole raising at Masset was the making of button blankets for some of the participants, especially the older people.

The carver of the pole was also called upon to create the designs that would be cut out and appliquéd onto specially shaped blankets. They took the form of one-colour eagle or raven crests and, of necessity, lacked the fine detail of box paintings or other graphic work.

These single-colour crest designs were foremost in the artist's mind when this bold, red Thunderbird became the subject for his next print, which was neither numbered nor signed. Thunderbird is distinguished from Eagle and Hawk by having the tip of its upper beak sharply curved back and below the lower beak.

In continuing to offer stores his new work, Davidson found that now, for the first time, he was selling more than he was giving away. Buyers had begun to seek out two-dimensional Northwest Coast art works.

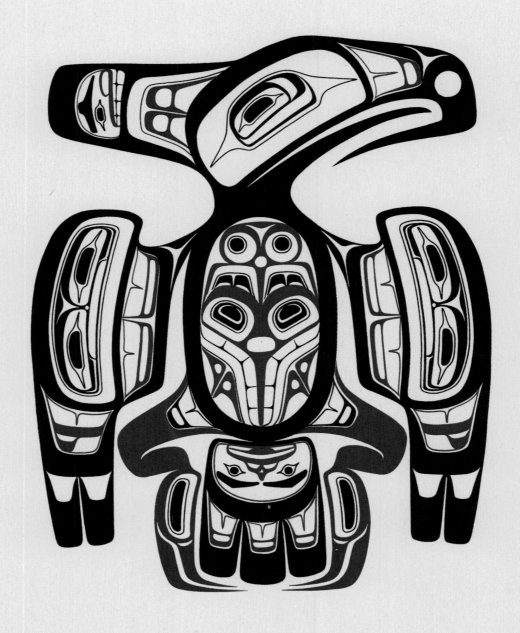

13 / Thunderbird
200 printed / 36 x 46 cm / 1970

This robust two-coloured Thunderbird with its well-formed ovoids and its firm balance and proportion reveals the artist's growing confidence. His feeling for structure had developed rapidly, his sense of design was greatly improved, and art purchasers were beginning to appreciate the classic Haida art form.

Tight, double-eyed ovoids form the Thunderbird's wing joints, and a woodpecker motif decorates the oval of the mythical bird's body. Legs and clawed feet, in red, are completely arranged around the tail to strengthen the well-organized symmetry of the design.

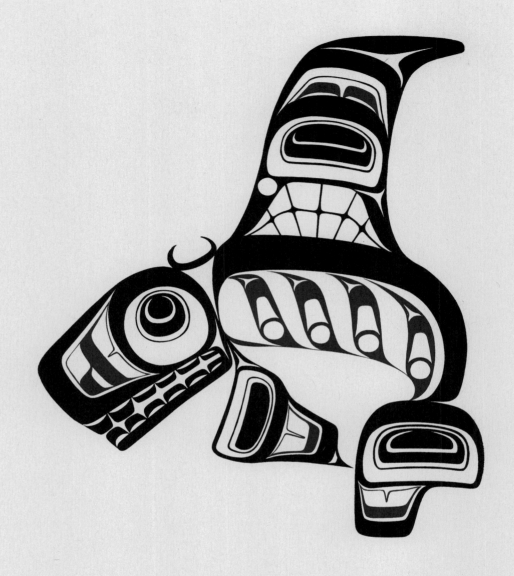

14 / Killer Whale
200 unsigned; 100 signed / 33 x 43; 33 x 51; 41 x 51 cm / 1970

With this Killer Whale portrayal a new era began for Robert Davidson, printmaker. It was the first numbered edition and the first to carry his signature.

The artist designed the print and cut the screen for it while visiting at 'Ksan. The printmaking was done for him by the school's students, and in return for this work, the 'Ksan Association kept two thirds of the copies. Davidson was allowed numbers 201 to 300, which he signed.

The first 200, though not signed by the artist, bear the words "by R.

Davidson" in the handwriting of fellow-artist Doreen Jensen. On pulling the prints, she marked them to identify their designer for the 'Ksan gift shop.

The Killer Whale crest has all the traditional identifying features: a prominent dorsal fin, a crescent-shaped blow hole between the body and the head, and a large mouth with teeth. Being in profile, the tail fluke is depicted asymmetrically.

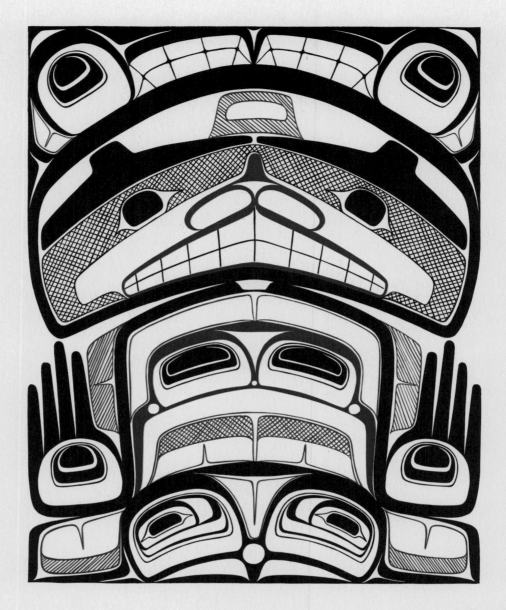

15 / Chest End Design
edition 110 / 37 x 46 cm / 1970

Still studying the intricate and often exquisite designs on old bentwood boxes, still learning from them, Davidson drew from his findings to create this design for the end of a storage chest, and for the first time he attempted a large area of cross-hatching.

Many of these cedar boxes and chests carried a complex design on the front and back, with only a simple motif on the ends, but when one was fully painted on all four planes, the ends usually depicted humans.

The elements that reveal the humanness of the figure in this print are the eyes, which are not enclosed within an ovoid, and the eyebrows, which have a distinctive shape not usually seen on animal portrayals. In addition, there are human hands on each side. These have elongated thumbs that almost meet beneath the chin, forming the figure's neck and delineating its body. The two ovoids at the base edge are the hip joints. Minimal legs fill the lower corners.

This design, signed, numbered and dated by the artist, became his first complete set of edition prints.

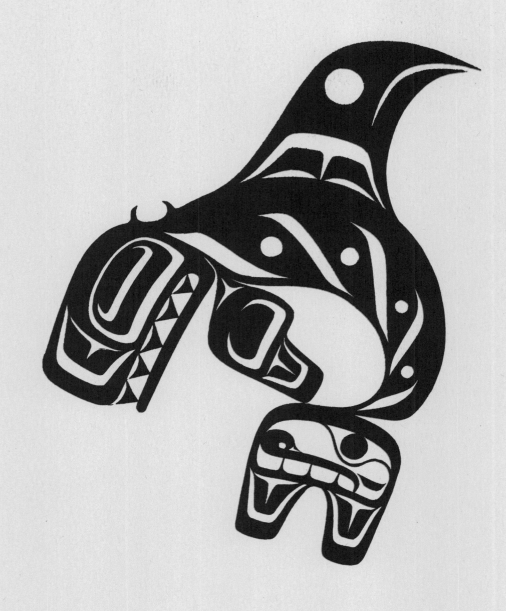

16 / Killer Whale
200 printed / 17 x 20 cm / 1970

Swept onto the annual merry-go-round of Christmas celebrations, Robert Davidson hastily produced a greeting card that he considers of poor design. His criticism is that the head is too small, the tail (designed in Edenshaw style) does not fit, and the fin is wrong for the body. The artist feels that he did not give the design enough time to mature as a whole — "like opening a bottle of wine before it has aged."

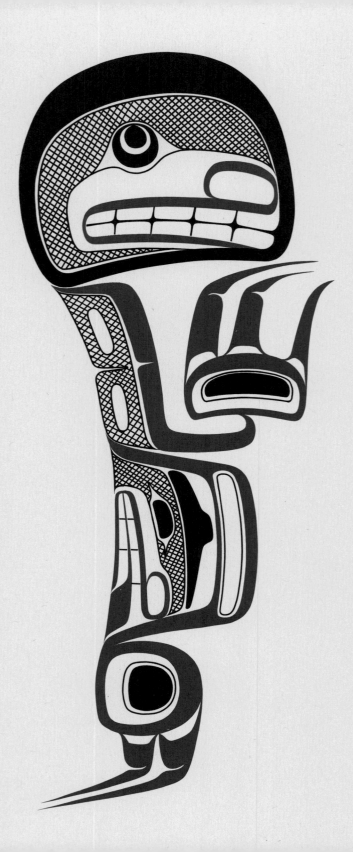

17 / Human
edition 137 / 29 x 64 cm / 1971

A doodle carved on a piece of scrap maple led to the creation of this intriguing work, which, despite its strange attributes, the artist sees as being human. Certainly the head is rendered like those of humans in much art of the Northwest Coast.

The design of *Human* advanced the graphics career of Robert Davidson yet another step. It was the first of his two-dimensional works, beyond small cards and copied killer whales, to depart from a symmetrical format, and it was an outgrowth of Davidson's having carved asymmetrical designs on silver spoons and bracelets. He enjoyed this new freedom and conceived his next two prints also as vertical asymmetrical designs.

By now Davidson had become fascinated with the silkscreen process and worked to achieve sharp, clean lines and perfect registration.

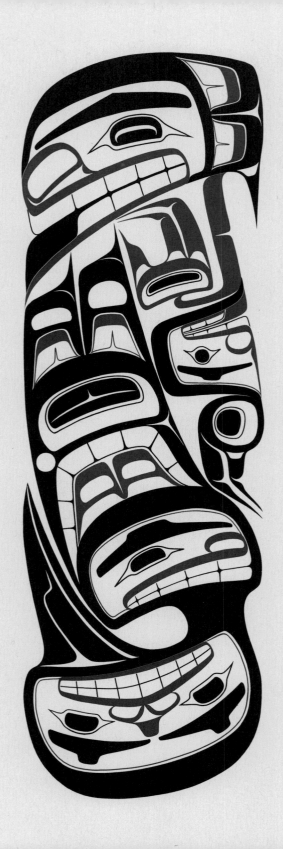

18 / Raven with a Broken Beak and the Blind Halibut Fisherman

edition 122 / 24 x 70 cm / 1971

This vertical and somewhat complex print, originally conceived by the artist as a design for a silver bracelet, recalls the legend of Raven and the blind halibut fisherman.

The upside-down head at the base is that of Raven, who acquired a broken beak through his encounter with the blind fisherman's hook. The beak is shown hanging down instead of jutting out horizontally, and from the neck a gracefully sweeping wing also delineates the bird's body.

The head at the top is that of the fisherman, but it also forms Raven's tail, hence the two feathers at the back of the head; just beneath is the clawed foot. Human features appearing on Raven's face symbolize the transformation of this mystical bird into human form.

In the art of the Haida, allowing the design to completely fill a given space takes precedence over the correct positioning or relationship of anatomical parts.

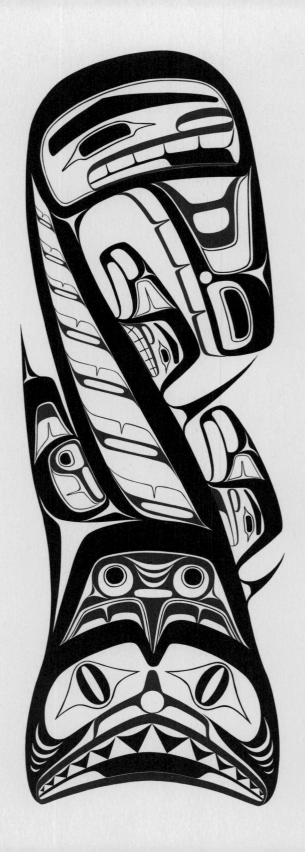

19 / Dogfish
edition 70 / 24 x 70 cm / 1971

In this third Dogfish print by Robert Davidson, the head of the small shark is represented as being seen from beneath; thus the high "forehead" is in fact its long pointed nose; beneath it are seen the down-curved mouth with the formidable array of teeth, and the four gill slits on each side. The long, slender body of this Dogfish carries fins and sharp pointed spines; it terminates in the curved-back tail.

Robert Davidson's interest in vertical, asymmetrical design continues with this print, which — like the previous one, *Raven with a Broken Beak and the Blind Halibut Fisherman* — is weighted at the base, curving up and over into a long S shape.

Intended for an edition of 100 prints, the Dogfish screen was inadvertently destroyed after the first 40 were pulled. The artist recut the screen and completed another 30, but a trip cut the work short, so though the prints are numbered as being of an edition of 100, only 70 have ever existed.

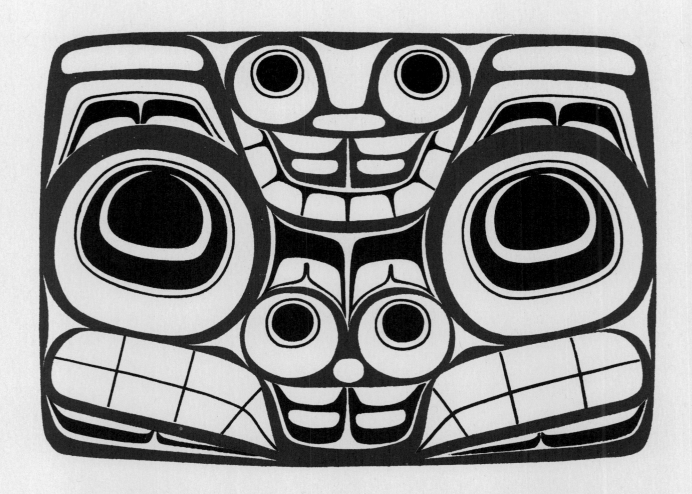

Still examining carved and painted items made by the great artists of the past, Davidson was deeply impressed by a round rattle of wood he saw in the Museum of the North, in Prince Rupert. So inspired was he by the beauty and spirit of it, that he carved a rattle with a similar design in 1970 while working at the Indian Pavilion at the Expo site in Montreal.

The rattle greatly pleased its carver; in fact, he enjoyed shaking it and singing with it so much that he decided not to sell it. But during the exhibition the rattle was stolen, and Davidson felt that he wanted to carve another right away since, traditionally, rattles were often made in pairs. Yet something held the carver back — perhaps the strange feeling he had that the previous owner of the original rattle objected to his having made a copy of it. Indeed, he came to feel it may have been stolen for this reason.

A year later, needing to get the rattle design out of his system, he adapted it to a rectangle and used it as the invitation card for the opening of his first one-man exhibition, held at the Centennial Museum, in February of 1971. Because of the shortage of time and the large number of invitations required, the wording inside was commercially printed.

Much of Davidson's work in the exhibition was sold on opening night, and the museum's gift shop was swamped with demands for his silkscreen prints. The exhibition not only displayed Davidson's versatility in wood and argillite carving, in silver work and jewellery making as well as printmaking, but it also established that the young Haida, descendant of Charles Edenshaw, was to be one of the great artists of this era.

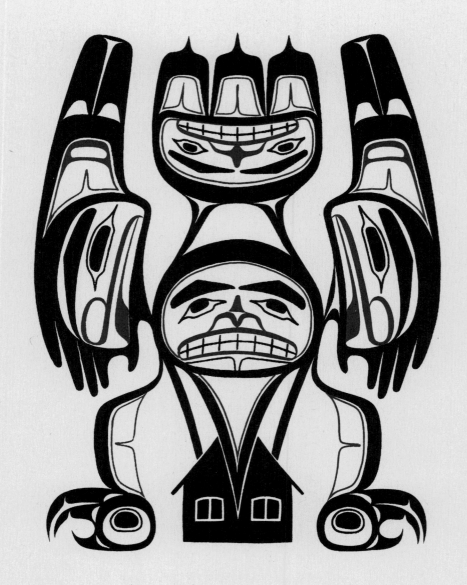

21 / Change of Address
75 printed / 15 x 18 cm / 1971

Finding the Pender Street studio in Vancouver unsatisfactory for a permanent home, the Davidsons bought a house and ten acres of land in the Fraser Valley.

They moved on the morning after the evening preview of Davidson's one-man exhibition at the Centennial Museum. A group of friends arrived at the studio and loaded the Davidsons' belongings into their assorted vehicles, and the long convoy made its way 44 miles to Whonnock.

To carry notification of the new address, and to mark yet another milestone in his life, Davidson printed and mailed out specially de-

signed cards. The idea for the card came to him from the Haida legend about Raven stealing a beaver lodge and carrying it away in his beak. Here, Raven has a human head, human hands emerging from the wings, and human faces in the large ovoid wing joints as well as in the three-feathered tail. Instead of the beaver lodge, Raven carries a house to symbolize the move. On either side are the legs and clawed feet.

Davidson had planned to run off 300 of these cards, but one of his dog's puppies chewed up the supply of paper, with the result that only seventy-five people received printed notice of the change of address.

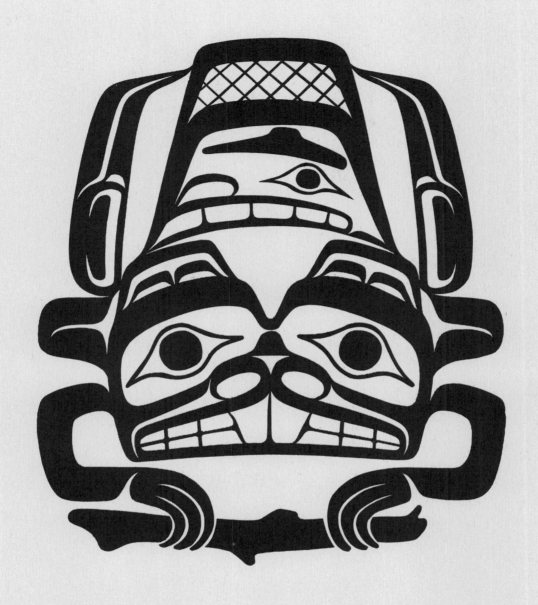

Adapted from a gold brooch that Davidson made, this Beaver was the first of his own designs to be sold as cards. It proved to be very popular and he reprinted it several times.

A large department store in Berne, Switzerland, invited Robert Davidson to partake in a program promoting Canadian furs and other imports, by demonstrating native Indian carving. As an expression of the art, the artist sold the Haida portrayal of the beaver to Swiss customers for two francs each — about 50 cents. The people were intrigued by the strange art style and bought many of the cards as souvenirs.

Stylized Beaver carries a realistic chewing stick in his front paws; hind legs flank each side of the body which terminates in the characteristic cross-hatched tail. The body bears a human face.

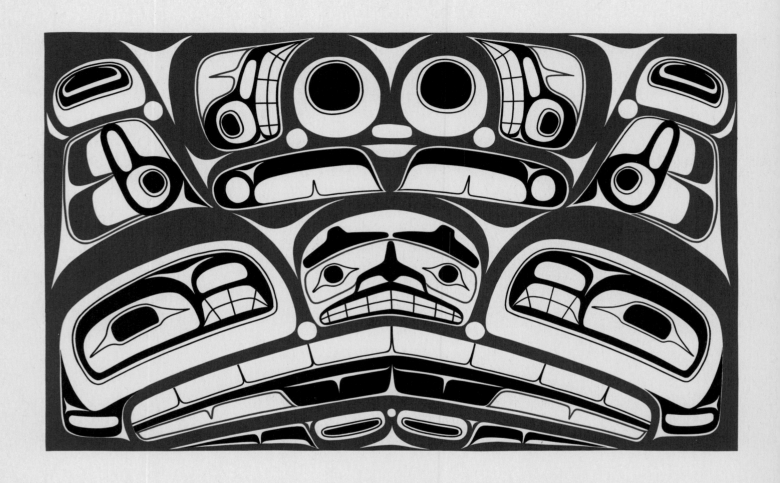

In Northwest Coast societies, entitlement to the use of a given crest had to be inherited or conferred by ceremony. Boxes were usually not decorated with easily identifiable crests, possibly so that they could be traded to or inherited by anyone.

Davidson's box, however, features Wolf. The front of the box depicts the head of the animal with eyes in large ovoids, a nose between, a mouth with large teeth, and ears extending up into the corners. The back of the box carries a very stylized and redistributed layout of the

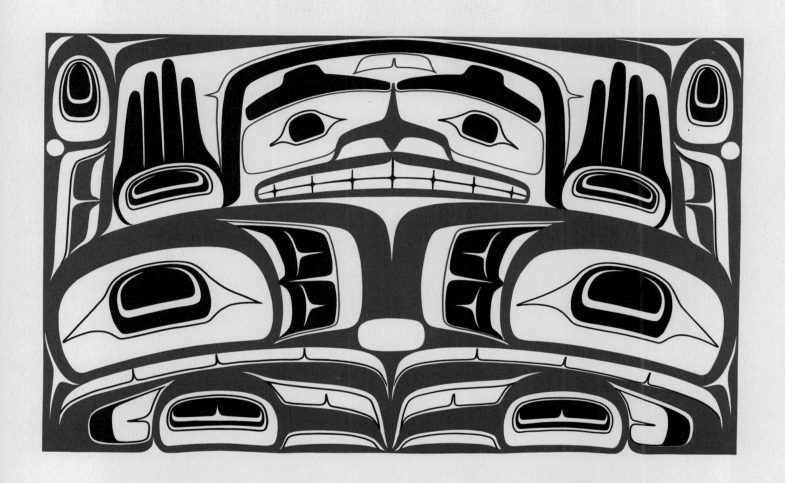

24 / Wolf Box, Back

edition 131 / 61 x 42 cm / 1972

rest of the animal in which body parts become difficult to identify. Wolf's body is decorated by a human head and two hands, the thumbs of which are extended to form the face outline; below, the animal's legs and clawed feet are doubled under.

These prints, which originated with a silver box the artist made while studying silver work under the supervision of Bill Reid, are unusual in that the form lines are in red rather than in the customary black of painted box designs.

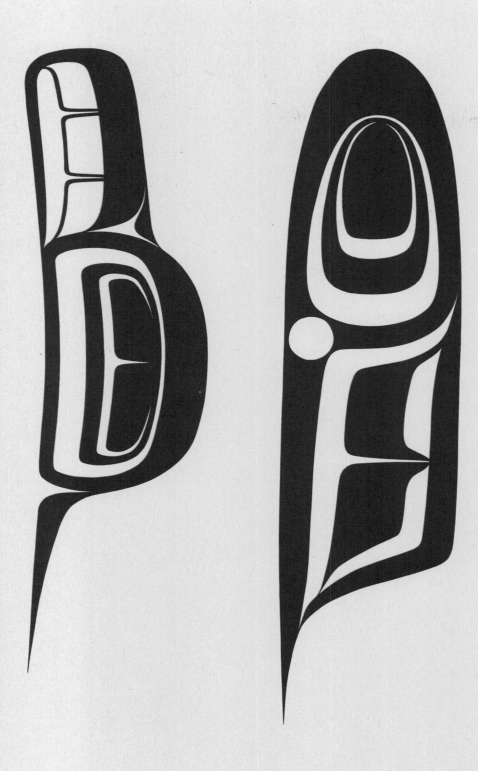

25 / 26 / 27 / 28 / 29 /
Feather Designs
approx. 200 - 250 of each printed / 18 x 53 cm
/ 1972

By now intent on the technique of fine printing, Davidson questioned the quality of his previous works. He decided to design something very simple and to concentrate on perfect printing. One after another, in varied reds that he mixed himself, he printed these one-colour feather patterns, using each to test his skill in cutting and pulling prints until eventually he was happy with the results.

Over a period of a year he completed 200 to 250 of each; they were neither numbered nor signed, and they sold at wholesale for 75 cents each. Insignificant as they might have seemed from their price tag, these feather prints are charming and elegant statements of design, each appearing poised for flight, and most are fine examples of the artist's perfection as printmaker.

Fortunate is the collector who has a set of all five.

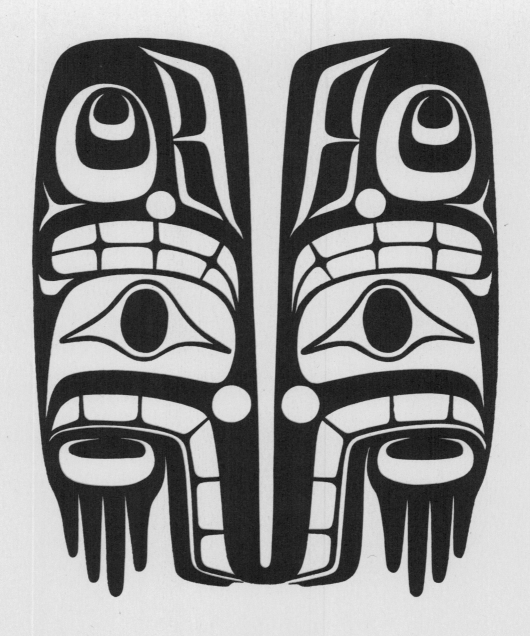

30 / Untitled
250 printed / 14 x 18 cm / 1972

For his 1972 Christmas card, Davidson used an idea from a silver bracelet he had made and which in turn had been inspired by an unusual bentwood box. He remembered the box for its unorthodox top edge, where a form line usually defines the extent of the head. Neither box, bracelet nor card represents a particular creature.

In the bracelet design, Davidson used the teeth of the uppermost face as a substitute for the missing form line. For the card he extended the design downwards with a hand, because it fitted so well. He then doubled the image to give it that much revered characteristic of Haida art: symmetry.

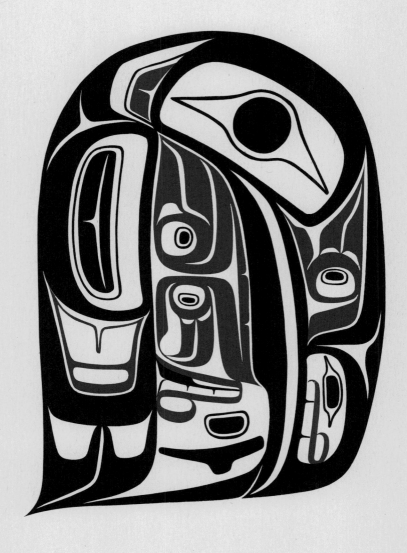

31 / Raven and Fetus
edition 150 / 29 x 32 cm / 1973

Prior to Davidson's pole raising, the elders of Old Masset held a meeting to discuss various procedures and ceremonies. Robert's wife, Susan, had endeared herself to the people of the village, and to the Davidson family in particular, and during the meeting she was called into the room. She did not know until afterwards that the speech she heard in the Haida language was officially giving her an Indian name. Those gathered were witness to this name-giving; Susan belonged to the Raven people.

Thus, when the time neared for the birth of the Davidson's first child, Robert was able to create a special design for the announcement. He depicted his wife as a Raven, portraying her in a protective attitude, head and beak bent down, sheltering the small unborn Raven that has its wings and legs bent in the upside-down pre-birth position.

A marvellously expressive and original piece of art, the design reflected a major event in the artist's life, but it was never used for its intended purpose. Instead it became a small edition of 150 prints, now much prized by collectors.

32 / Sara's Birth Announcement

edition 503 / 20 prints 29 x 32 cm; 483 cards 14 x 18 cm / 1973

The natural birthing of the Davidson's first child was a profoundly moving experience for both parents. The father's twelve-hour participation in the event impressed him so greatly that he created a second design, asking his wife to choose which should become the birth announcement card. She chose the new design.

Davidson marked the importance of the occasion by making — for the first time — a signed limited edition of a personal card. The first twenty were made as prints, the rest contained the message:

sara florence davidson
3 . 4 . 1973
8.6 oz 11.50 pm

In a sensitive portrayal, the card shows the Raven mother as both human and Raven at the same time by having attributes of each. A pair of lungs in the body cavity emphasize her regulated breathing, and partially closed eyes indicate her bearing down as the child emerges.

The baby, with a human body, is also a Raven, since all Haida people trace their lineage through their mother. Looking very newborn with her small immature head, the infant climbs out of the mother's body much as did the first humans when Raven, the creator, summoned the original Haida people from a clam shell.

33 / Raven with Broken Beak
edition 116 / 29 x 32 cm / 1973

Raven, culture hero and trickster in Northwest Coast Indian legend, could transform himself into human form at will. In this print, the transformation is symbolized by the human hands emerging from the upper part of the wings and by the human head above the downhanging beak, which signifies that it is broken. The three-feathered tail is seen upturned, and on each side is a bent leg with a clawed foot, but the body itself is only implied.

The general form of this Raven is an interesting rearrangement from the one that originally carried a house in his beak to announce the Davidson's change of abode (#21), and it worked in well with the artist's run of square-shaped prints.

This compact print of Killer Whale was designed around a legend and cleverly incorporates the man and his wife who, the legend says, were carried off by the sea mammal.

The wife is pictured within the dorsal fin, where the ovoid forms her head and where the body, with a hand, fills the lower fin. Her husband is seen horizontally within the whale's tail fluke, which

curves underneath; the large ovoid becomes his head and the rest of him is represented by an arm and a leg filling the U shape. For extra measure, another head fills the area of the whale's body, with a smaller head in the snout.

Davidson was pleased with the squared format of the previous two designs and often returned to that shape.

35 / Killer Whale Fin

edition 165 / 28 x 64 cm / 1973

A silver bracelet he had made provided the idea for Davidson's 1972 Christmas card, and the Christmas card subsequently initiated a new print. The artist halved the double design (#30), enlarged it, altered it, printed it in two colours and titled it *Abstract*. Evidently such a modern art term was not acceptable for a work of Haida art, which is renowned for classic traditionalism; few would buy the print.

Davidson renamed the elongated design *Killer Whale Fin* and raised the price. The edition sold out.

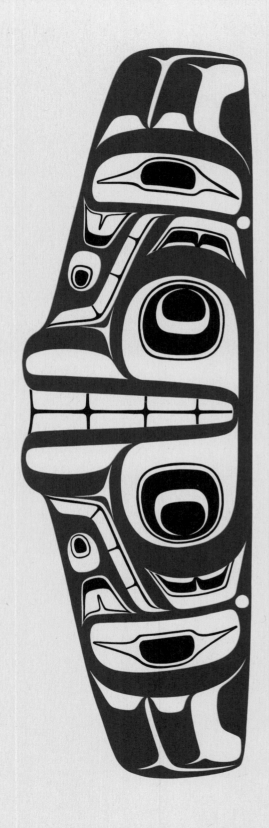

36 / Grizzly Bear
edition 215 / 24 x 51 cm / 1973

Robert Davidson had been doing a lot of commission work in silver in his well-equipped studio, and it gave him satisfaction to take a good design, rework it, and see it realized in its final development as a two-colour print.

Grizzly Bear was another of the prints that originated with a silver bracelet, and, as often happened when he developed a print from silver, the form lines were executed in red not black.

Davidson's Grizzly Bear seems to reflect itself: the two heads share the same mouth, with an arm and claws at top and bottom completing the brief statement of this animal. It is another example of shape and space taking precedence over naturalistic portrayal.

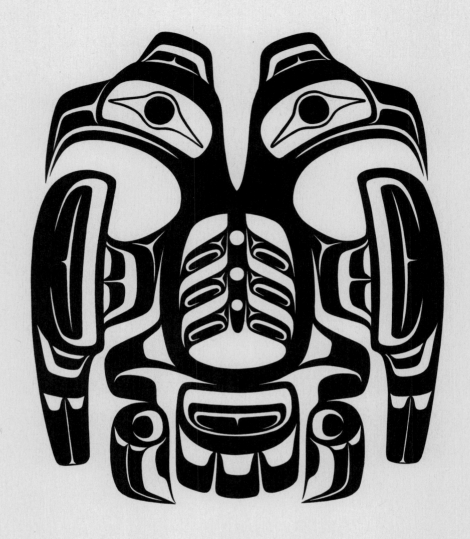

37 / Mother's Memorial
90 printed / 37 x 46 cm / 1973

In the fall of 1972 Davidson's mother, Vivian, drowned as the result of a boating accident that occurred while she was fishing with his father in Masset Inlet.

Observing an ancient Haida custom, Claude Davidson gave a memorial potlatch for his wife one year after her death. He also gave a second potlatch in Hydaberg, Alaska, which was the home of her family. Robert Davidson made silkscreen prints to be given away at the Old Masset feast.

Double-headed Eagle is a crest that belonged to his mother, and he printed it in black, using classical symmetry for the dignified effect he sought.

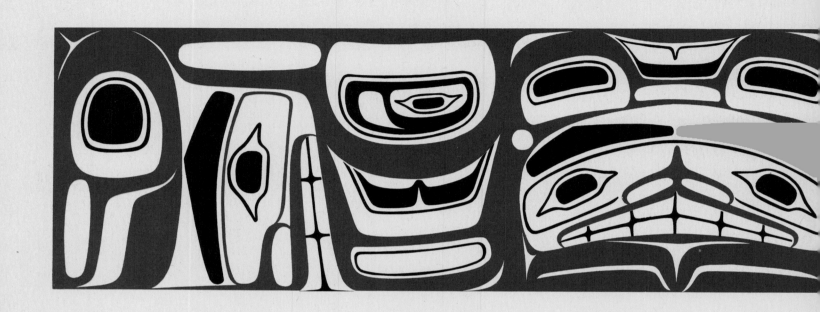

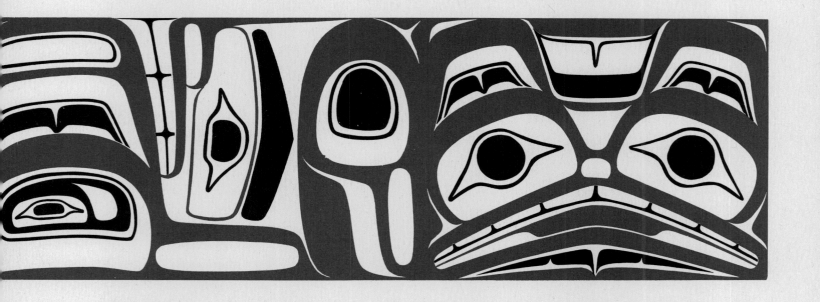

38 / Bentwood Box
200 printed / 44 x 8 cm / 1973

The Davidsons' Christmas card for 1973 depicted the four sides of a painted bentwood box, though Davidson based the design on that of a wooden sugar bowl he had made in box form. The card was scored in three places where a cedar plank would have been kerfed for shaping into a box, and those who responded to this clue found that if bent, the card became a miniature box — a Christmas present.

Wanting his friends to discover the gift for themselves, Robert added no instructions to his greeting.

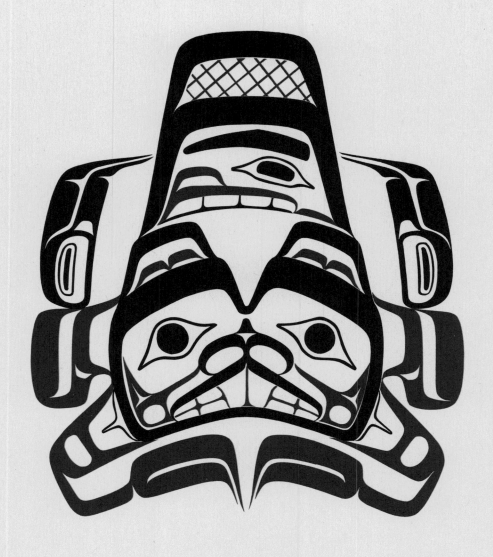

After two years Davidson reworked and refined a one-colour card (#22) that had sold well in Canada as well as in Switzerland. Maintaining the basic structure of his original Beaver, he reorganized the body proportions, improved the front legs, printed it in two colours and released it as an edition print.

As usual, Beaver is identifiable by large incisor teeth, ears and cross-hatched tail, but lacks the customary chewing stick. The body of the animal lies between the ears and tail, and bears a human face to symbolize its human associations.

This is one of several of the artist's prints that have been made into art cards, and it is still a strong favourite.

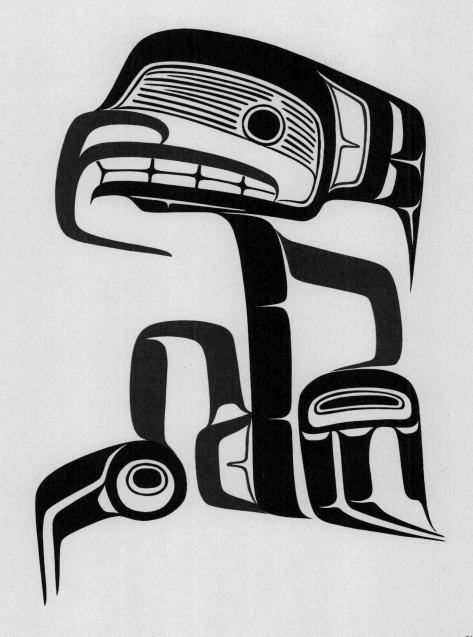

40 / Sea Ghost
edition 343 / 29 x 32 cm / 1974

One of the lesser-known subjects of Haida myth is the Sea Ghost, a human-like creature with long black hair and birdlike beak, who clings to the fur of a Sea Bear.

In this print the horizontal lines on the head indicate the long hair, and the fin extending from the back of the head shows that the creature is of the sea. On the Sea Ghost's back there is said to be a lump which the artist has formed by the positioning of the arm.

The strong quality that marks Davidson's work is achieved here through the bold use of line and the pleasing balance of black and red elements. It is a simple but positive statement.

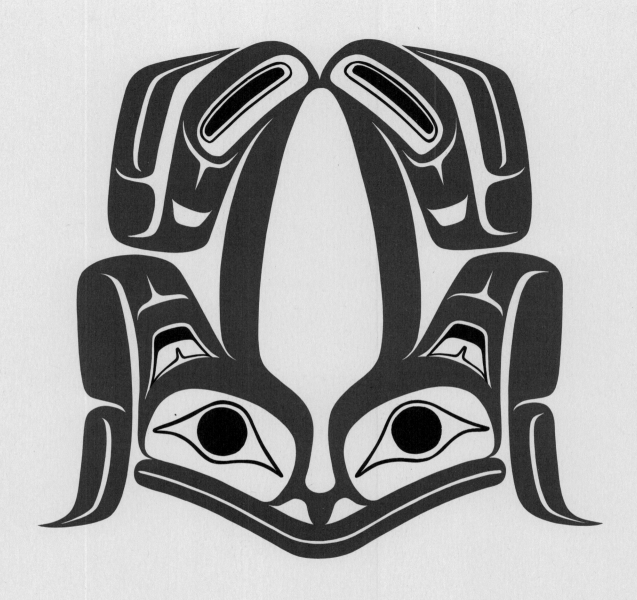

41 / Frog
edition 231 / 29 x 32 cm / 1974

Frog, frequently seen in carved and painted art works of the Haida, is elegantly portrayed in a two-dimensional print. Davidson originally designed the motif for a button blanket being made by his grandmother for sale to a customer.

Appliqué work on such dance blankets calls for simplicity, and the economy of line and form is evident in this print. Touches of black offset the clean, bold lines of the all-red Frog. The classic attributes of wide mouth and large eyes, and the very frog-like attitude of the creature make this unmistakably Haida, and distinctly Davidson.

This is another of the artist's designs made into an art card.

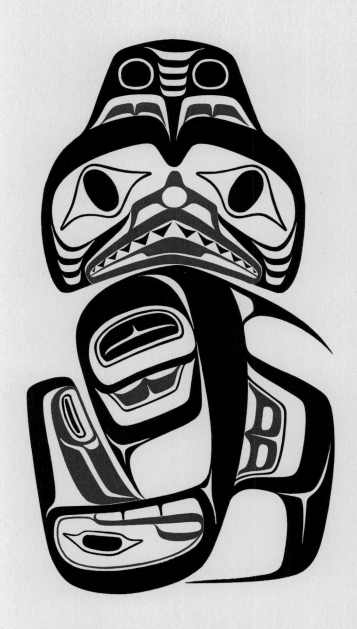

42 / Dogfish
edition 330 / 29 x 32 cm / 1974

This spirited Dogfish expresses movement through its large fins and tail, which dominate the body. Other characteristic symbols for this member of the shark family are the high domed head, gill slits and down-turned mouth with sharp pointed teeth.

The vertical design was initially created for a large silver pendant. The artist was pleased with the result and incorporated the motif into a 6-inch carved argillite plate, eventually reworking it once again into a two-colour print.

When making a print from the design of a piece of jewellery, Davidson tended to let red dominate; subconsciously he may have been trying to maintain the brightness and lightness of silver. This print was reworked from the carved dish, and the rich colour of the argillite may have influenced the artist to make strong use of black in the printed version.

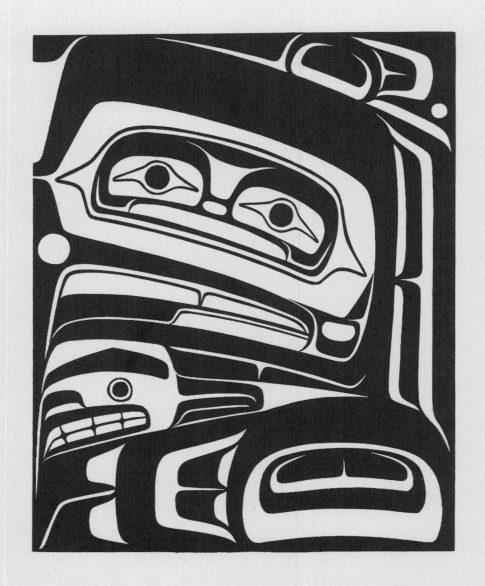

43 / Raven with Broken Beak
250 printed / 14 x 18 cm / 1974

In a very strong composition, Davidson took one of his favourite themes — Raven with broken beak — and, in the distributive style, filled every part of the rectangular shape with the motif. This complete filling of space was often practised by Haida artists, to the point of making the subject almost totally abstracted.

Davidson's bold, red Raven, though printed on a card for his annual Christmas greeting, conveys the feeling of being a much larger print. His Raven is seen in profile facing left, with a double-eye motif within the large ovoid of the head. The upper beak runs vertically down the left edge of the card, with the lower beak running into it from below the head. Across the base is Raven's wing, lying horizontally, and tucked between head and wing is a human child, probably a subconscious element influenced by the artist's new infant.

The solid structure and vigorous non-configurative style of this design begins a new self-confident trend in Robert Davidson's graphic work that reflects his increasing stature as a prominent Northwest Coast artist.

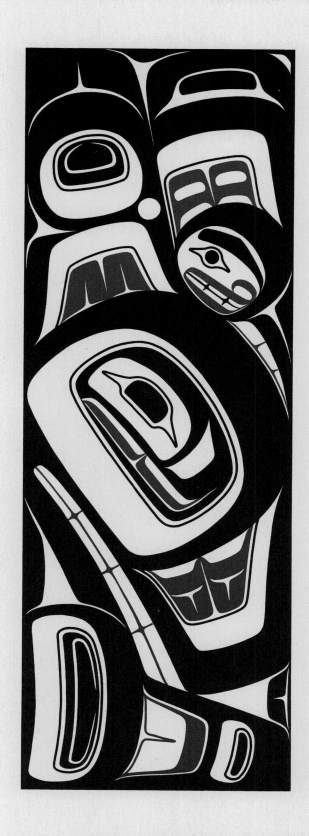

44 / Killer Whale
edition 295 / 15 x 44 cm / 1975

The previous three Killer Whale designs by Robert Davidson were each clearly defined crest figures arranged within a free space.

Commissioned to carve a wooden door for a private home, the artist again used the subject of the whale, composing the design for the outside of the door to fit completely within the confines of the required shape. The anatomy of the whale was rearranged in abstract form, with the basic elements of the art balancing and melding in a sophisticated way that is the very essence of complex Haida designs.

Instead of making payment for the door, the client agreed to trade his work for that of the artist — thus Davidson benefitted from several years of dental care without receiving the bills.

The print, translated from the carved door into black and red, prominently features the whale's head (facing right and down), with an eye in the large ovoid, the snout and the mouth with two rows of teeth. Above and to the left rises the dorsal fin, and next to it a small round face decorates the whale's blow hole. At the base the tail fluke in profile completes a tightly knit composition.

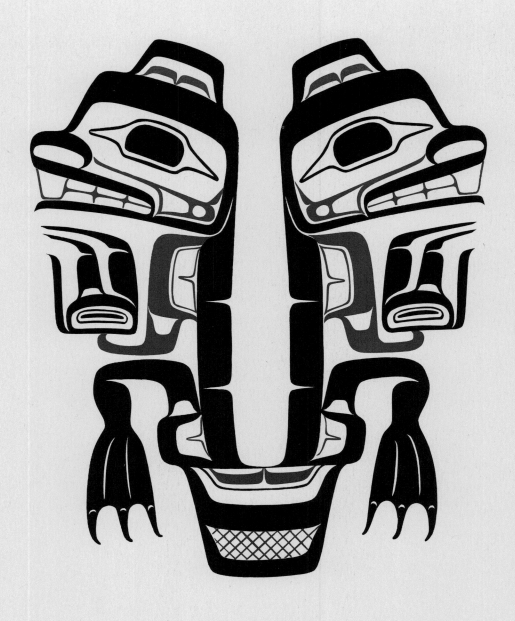

45 / Split Beaver

edition 303 / 29 x 32 cm / 1975

At the north end of the Queen Charlotte Islands, where the Yakoun River runs into Masset Inlet, the rights to fish salmon have been owned by the people of Masset for hundreds, maybe thousands of years. Some villagers still return annually to stretch their nets across the river in spring and to camp in cabins maintained by their families.

Though living in Whonnock, Robert Davidson returned to the camp in 1975 with his wife and young daughter Sara to catch the migrating sockeye and to smoke and preserve it for winter.

Checking the nets one day, he found that a beaver had become entangled in the mesh, and while releasing it he was impressed by how large the webbed feet were. With this proportion in mind he created a new print, a split figure prominently displaying the webbed hind feet.

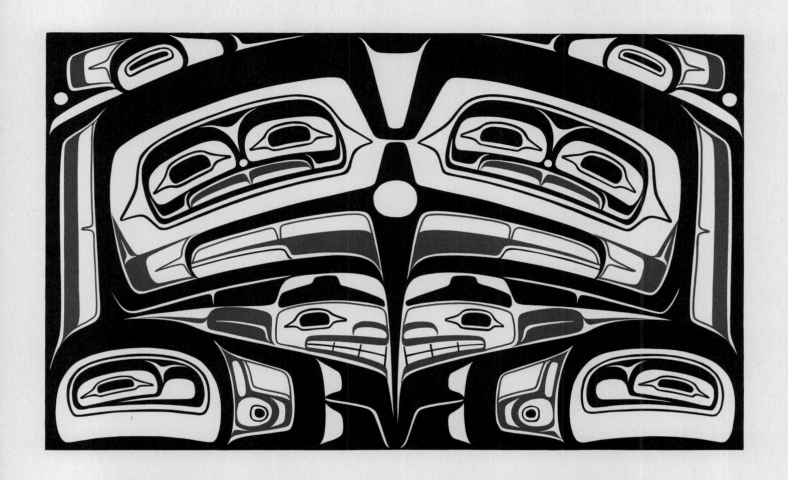

46 / Raven with Broken Beak
edition 149 / 35 x 28 cm / 1975

Davidson's bold red Christmas card of 1974 (#43) became the basis of a new print the following year.

The card showed Raven, with broken beak, facing left in profile. By reworking the design and adding a mirror image to the left side, he created Raven facing front, with the beak running vertically down the centre. In the lower section, a pair of wings fold in towards each other, giving symmetry to the highly stylized design.

47 / Raven-finned Killer Whale
300 printed / 13 x 56 cm / 1975

Another example of a motif contained within a specific shape is this long, slender whale print. Davidson was commissioned to make a silver letter opener for an anniversary gift, and for it created a design compatible with the object. On one side he carved away the negative areas, using cross-hatching for the same areas on the reverse.

The tall dorsal fin of the whale, which resembled a raven head, formed the handle of the letter opener, and the blade carried the pectoral fin and one half of the tail flukes.

Because of a suggestion that there was a need for inexpensive silkscreen reproductions of his work, he enlarged the whale design and printed 300. They were not a signed edition and sold for a low price.

48 / Negative and Positive
250 printed / 10 x 22 cm / 1975

Growing and maturing as a person as well as an artist, Davidson could now manipulate the art form to convey his thoughts and ideas. He had been toying with the theme of negative/positive, and expressed this in an unusual Christmas card, his first conscious effort to deal with the subject.

Using a face design he had carved on the inside of the door referred to in #44 he repeated it vertically within two heavy U-form shapes. The black and red face on white represents positive and the black on red, negative, the two oscillating at both ends of the rectangular boundary.

For this two-colour print, the red was run first in a large area. The artist found the printing boring and tedious, but when the black was overprinted suddenly the whole design sprang to life, and the result was deeply satisfying to him.

49 / Wedding Invitation
500 printed / 14 x 18 cm / 1976

In 1976, Robert Davidson's father, Claude, remarried. The civil ceremony in the nearby town was simple, but the celebration which followed in the village was lavish and largely traditional.

Claude and his bride, Sarah, wore elaborate costumes embellished with fur, beading and abalone shell. White fur cascaded from the carved headdress and trimmed the groom's hide leggings. The couple encouraged the guests to wear ceremonial regalia, particularly the colourful button blankets, and many did. There was feasting, dancing and drumming. Special Haida songs were sung and, according to custom, the singers were paid.

Robert Davidson designed and personally printed 500 invitation cards. Because his father is a Raven, this crest was portrayed on the cover; not owning a crest, his wife was shown in the centre as a woman wearing a labret.

50 / 51 / 52 / Moon
edition 274 red and blue-green on black; edition 248 black and
blue-green on beige; edition 364 blue-green on black / 43 x 43 cm /
1976

One cool, crisp evening as Davidson walked from his studio to the house, the crescent moon stood out against the dark sky like a bright piece of a circle. The beauty of it impressed him, and the shape challenged him, for a circle is the most difficult with which to work in Northwest Coast art.

He saw the moon as a pendant, hanging there, and it became the beginning of a series of art works formed within a circle. He was to use the shape in many ways, from a small silver pendant to a large wooden screen, as well as in several silkscreen prints. From the pendant design — which was the moon, crescent-shaped but containing a human — he created an unusual series of prints, repeating the design using different colour combinations and backgrounds in order to experience the moon in different ways. The use of the red with the blue-green against a totally black background is indeed dramatic.

Davidson was intrigued with the type of blue-green that had been used in the past, and so for this print he experimented with the mixing of pigments to achieve the colour he wanted. Pleased with the result, he used it again on subsequent prints.

Many months later, when Davidson began to be more aware of himself and his relationship to his work, he saw that the man in the moon was himself. The hand forming the mouth symbolized for him the use of his hands as a mouthpiece since he communicated through his art.

Although buyers were initially unaccepting of a non-traditional design, these spirited prints revealed an innovative artist willing to break with, as well as cling to, tradition; an artist moving in new directions of experiment and control.

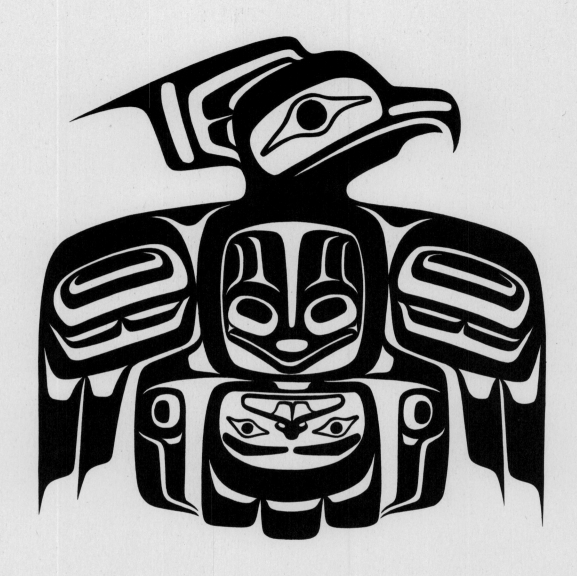

53 / Eagle: Oliver Adam's Potlatch Invitation

500 cards / 14 x 18 cm / 1976

With the death of Chief William Matthews at ninety-one years of age, on 4 February 1974, Oliver Adams inherited the title and position of chief of the Masset tribe, becoming Chief Galaa. Within two years he had accumulated the wealth and material goods required for giving a potlatch to validate that position in accordance with ancient Haida customs. He asked Robert Davidson to design an invitation card and also to make 500 silkscreen prints to give away at the feast.

Davidson was pleased and honoured to be able to contribute to the potlatch, and felt that because the new chief was of his moiety (Eagle) he should donate his time and work. However, his grand-

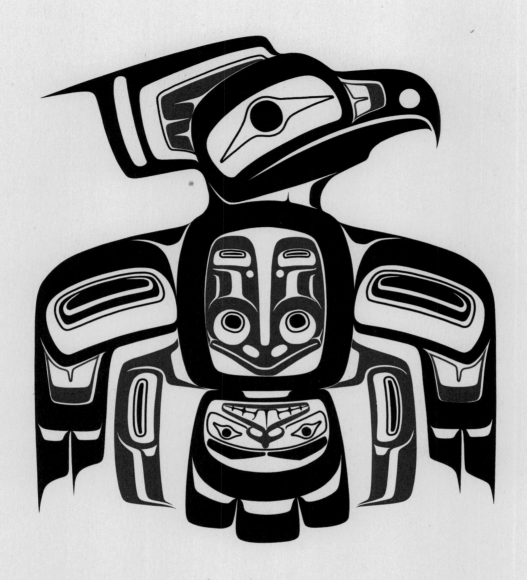

54 / Eagle: Oliver Adam's Potlatch Gift

500 printed / 36 x 41 cm / 1976

mother advised him that by tradition a person hired for a specific purpose must be paid.

Because Chief Oliver Adams was of the Eagle crest, having Frog and Beaver as sub-crests, Davidson's Eagle design incorporates a frog within the body and a beaver head in the tail. A two-colour rendition of the same design, with refinements, became the gift.

At the conclusion of the two-day ceremony and celebration, the newly validated chief made a profound and moving speech that enthralled his audience. He gave away quantities of gifts, and publicly paid those who had contributed to his investiture.

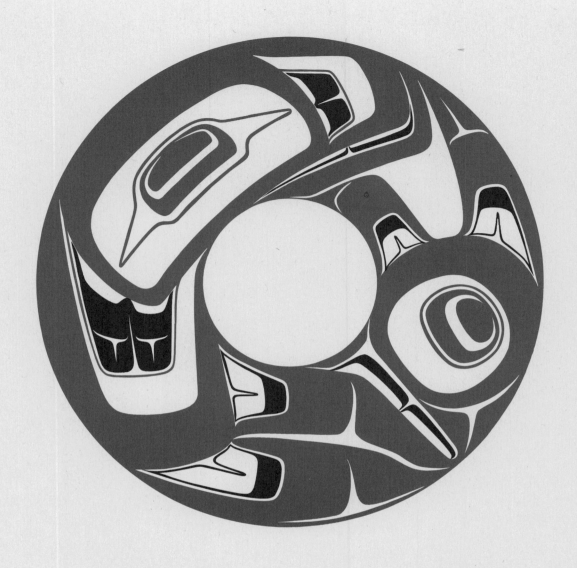

55 / Sea Monster
edition 238 / 37 x 37 cm / 1976

Having explored the limits of vertical, horizontal and square shapes, Davidson continued to develop the circle motif. He created a highly involved Sea Monster design in the format of the paintings made on spruce root hats worn by wealthy Haida women of the past.

Davidson carved the design first as a circular silver pendant, transposed it to a print, and then reworked it as two circles on a large cedarwood screen for an office in the Canadian Broadcasting Corporation building in Vancouver. Introducing subtlety and surprise again into his work, he made one circle different from the other in hard-to-perceive ways that become obvious when they are pointed out.

The mythical Sea Monster is seen coiled around the circle, and the head, facing right, is dominated by the powerful gaze of the eye. Below the eye, at the right, can be seen the mouth with teeth. The body and flipper coil in a counter-clockwise direction, conveying the movement of a writhing monster.

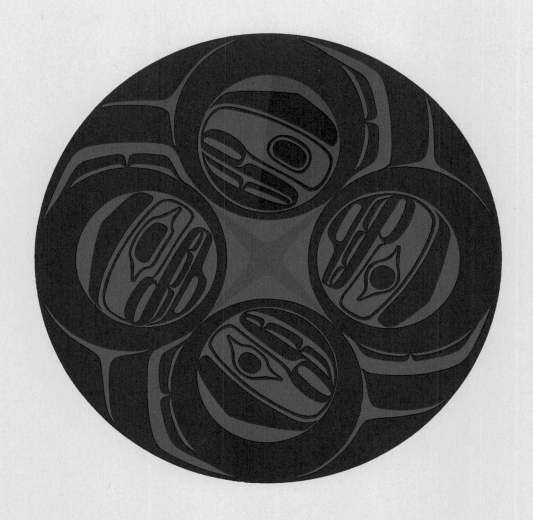

On 6 April 1976 Robert Davidson again shared with his wife the birthing of their second child, a boy, and again it was a powerful experience.

As he left the hospital, elated by the spirituality of the event, he came face to face with a half moon shining in a clear night sky. Davidson had been searching for an idea for the birth announcement card, and the moon once more took on a special meaning. The artist used its shape to inventively create a card which became a family portrait, and he made it a numbered edition which included twenty prints.

The four segments enclosed within the large circle represent the four members of the family, and the portrayals identify each of these persons. At the top is Benjamin with a newborn look: no teeth and an immature eye without the eyelid. Because he was born at the half moon, his father introduced a hidden subtlety by overprinting (blue on red) a vertical half moon within the baby's circle. The resulting change of colour is so slight that it must catch the light a certain way to become visible.

To the left is the mother, mature, with a labret in her lower lip; beneath is the artist, adult, with no lip ornament; and to the right is young Sara with a wide-eyed childish look and a labret to indicate that she is female. The centre of the design also carries a four-pointed star shape, overprinted in the same manner as the half moon. The star, of the kind often painted on the top of woven Haida hats, links together the four members of the family.

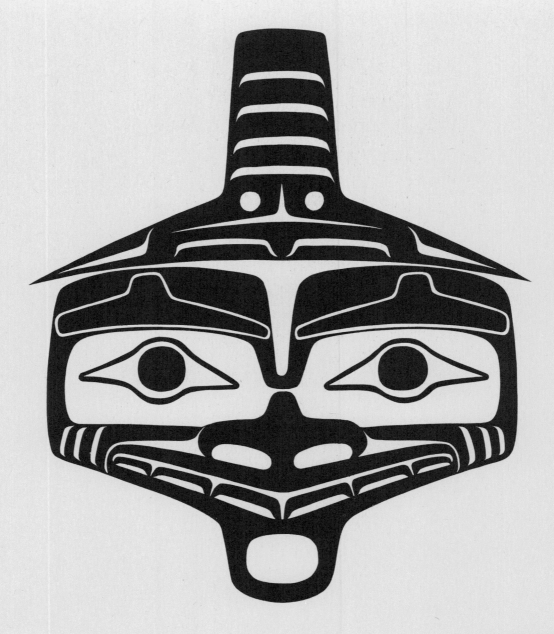

From subconsciously making statements about himself, as in the Moon print, Davidson began deliberately to design around the thoughts or feelings that he experienced during introspective moments.

The face on this transformation card is that of a smiling woman — a woman of wealth and rank, as shown through the labret in her lower lip and the multi-ringed hat, for each ring denotes a potlatch given.

The printing of the outer face of the card is in a light red; it opens up to reveal the inner face, which is identical but of a deeper, richer red.

The subtle message in the Christmas card expressed the artist's newfound perception of himself and others: that we all have two selves. The outer self, the one we normally show, is only a pale image of the inner, deeper self; when that shallow outer cover opens, the real self beneath is revealed.

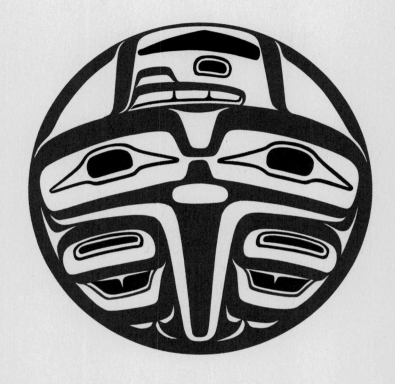

58 / 59 / 60 / 61 / Four Circles

Raven, edition 182; *Eagle*, edition 140; *Whale*, edition 127; *Frog*, edition 172 / 20 x 20 cm / 1977

The magical, mystical number for the people of the Northwest Coast was four. It permeated their culture and influenced their traditions in countless ways; songs and dances were often repeated four times, rituals were performed in fours, and myths were often built on the occurrence of four events, or repetitions of four.

Reflecting this tradition, Robert Davidson brought out an unusual set of four prints that marked a turning point in his work as a printmaker. They became the first that the artist entrusted to the photographic process in silkscreen printing, and he demanded of the commercial printer the same high standard of printing that he had achieved in his own studio.

The design of these four prints is unique in that each embodies only the essence of the creature it portrays through the minimal use of line. The negative and positive shapes interlock to provide the necessary identifying features with amazing economy of detail. Originally designed as silver pendants, in graphic form the circle motifs become a striking quartet.

The rendering of one circle in black with touches of red makes a strong counterpoint for the three predominantly red designs having accents of black.

58 / Raven with Broken Beak, subject of a Haida myth, is reduced to head and wings. With the head facing front, the broken beak hangs down the centre, flanked on each side by pointed wings that almost meet at the base. A small human head at the top is the ever-present reminder that Raven can transform himself into human form at will.

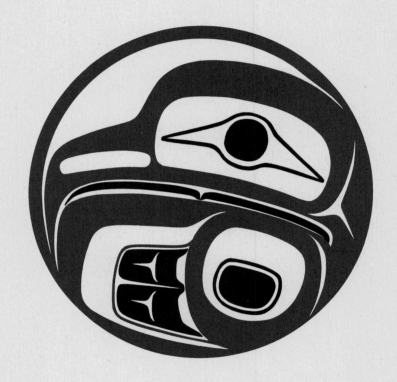

59 / Eagle is seen in profile facing left, his head and wing being all that is required. The keynote for Eagle here is the downcurved beak, and in an interesting contraction the artist has used the line of the lower beak to form the outline of the wing below it. In its minimal form, the wing has two black feathers and an ovoid joint.

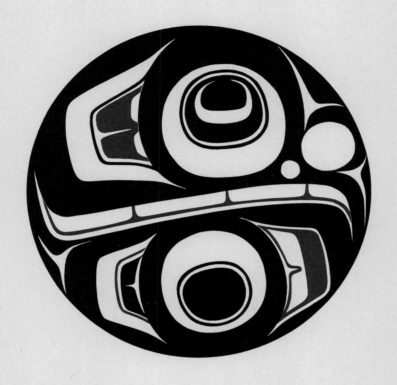

60 / Killer Whale, has been reduced to an absolute minimum; the head, eye, mouth, flippers and necessary blow hole, all flowing within the circular shape, combine to create a bold and fluid design of near abstraction.

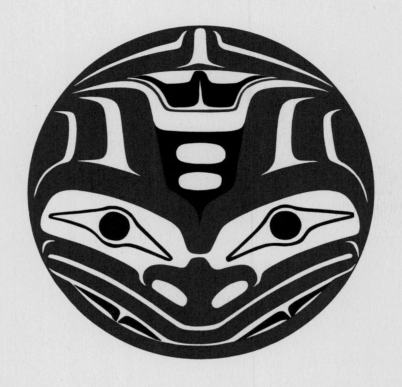

61 / Frog is shown with characteristic wide mouth having no teeth; arms and legs are suggested through the fingers and toes arranged behind the head, with the central black element representing the body.

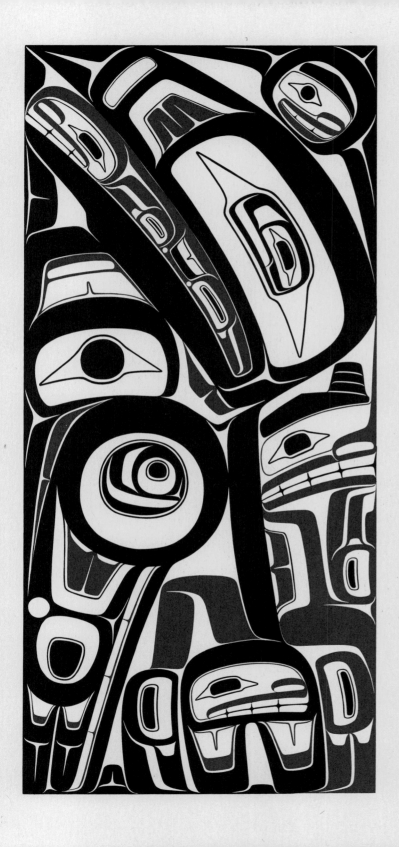

62 / Raven Stealing the Moon
edition 75 / 43 x 77 cm / 1977

An enchanting and elaborate Haida legend tells how Raven created the world in the beginning when all was darkness; how Raven, through trickery, stole the sun, moon and stars from a chief who kept them hidden in three wooden boxes, and how he flew up and flung them into the sky where they have remained ever since, bringing light to the world.

A complex and highly sophisticated rendering of Raven stealing the moon is depicted in this print, which had its origins in a seven-foot-tall carved wooden panel. The panel, commissioned in 1972 for a home for the aged in Victoria, was to be featured on the high stone fireplace in the spacious lounge, which also incorporated a minstrel gallery. However, a change of plan resulted in a formal decor for the lounge, the stone facing was eliminated and the finished panel was now considered unsuitable. Stored for years in the building's basement, the panel was recently rescued from among crates of pop bottles and is now in the hands of a private collector.

Raven can be seen in profile, his head filling the top half of the print, looking up to the left. In his beak he holds the crescent moon, a figure in red having a head and body. Raven's wing, extending down towards the lower left corner, is attached to his body, which he shares with that of the chief (seen on the right margin) who wears a multi-ringed hat to denote his status. One leg and foot of Raven is placed between his wing and tail; the other leg is also shared by the chief.

The face in the top right corner, with three rays emanating from it, is the sun, already placed in the sky by Raven.

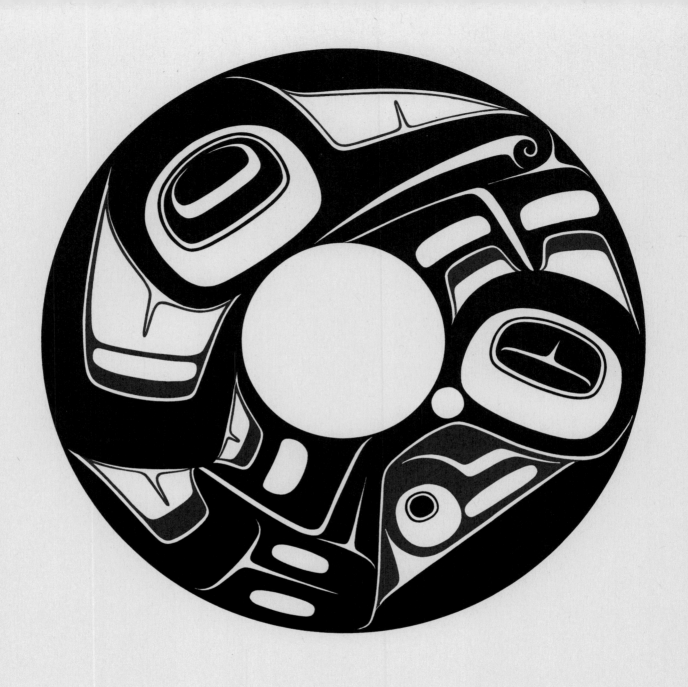

One hot summer day a Monarch butterfly landed on Robert Davidson, and he was able to study the beautiful insect closely. He observed with special fascination the insect's proboscis, and for the first time he was able to understand the curled element used to symbolize the butterfly in Haida design.

In 1970 he made a silver spoon and engraved it with a butterfly design; later he adapted the design to fit a bracelet, and eventually made a beautiful silver butterfly pendant for his young daughter, Sara.

Years later Davidson had the idea of creating a double image print, two images that visually bounced back and forth in reflection of each other. Still intrigued with the difficulty of designing within circles, he chose to use the butterfly motif of his daughter's pendant to express

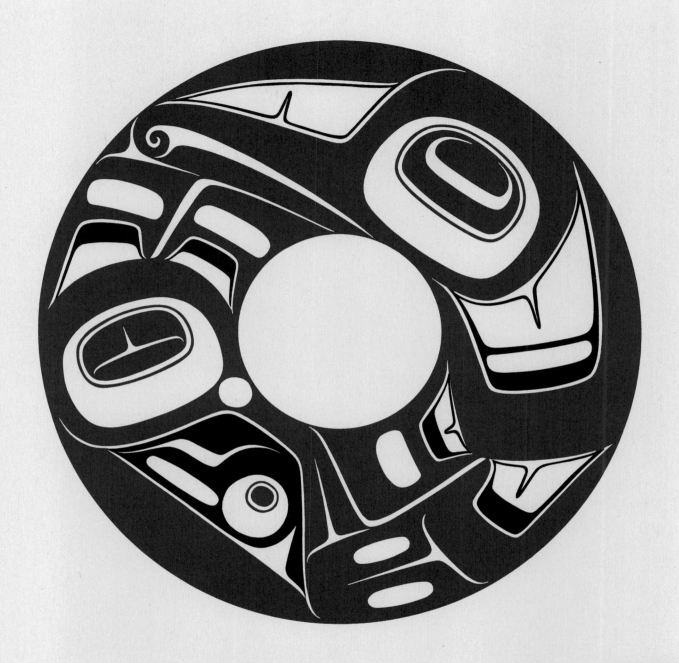

63 / Butterflies
edition 75 / 57 x 32 cm / 1977

this idea on paper. In profile, the two insects face each other, each head discernible by its eye and long curling proboscis, each with the rest of the body and wings in abstracted form coiling around the circle shape.

Writing about this double image print in the Northwest Coast Indian Artists Guild catalogue of 1977, archaeologist George McDonald, of the Museum of Man in Ottawa, recalled that to the Haida people butterflies were messengers of departed souls. He saw the hole in the centre of Davidson's design as representing the entry into both the world above and the world below, a hole through which souls passed in their journeys and through which messages were sent.

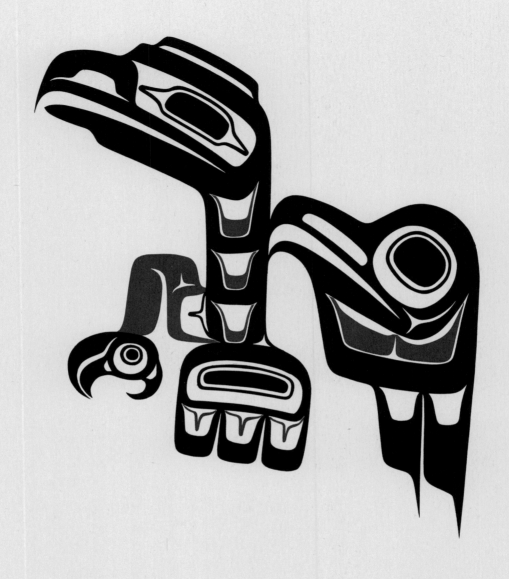

64 / Ordination Invitation

750 printed / 14 x 18 cm / 1977

Alfred Davidson, one of three men to be ordained Deacon in the Church of St. John the Evangelist, Old Masset, asked his nephew Robert to design a card of invitation for the ceremony to be held 9 October 1977.

Once again, as in 1969, the artist had to represent the Eagle and Raven crests of the village on a single card. He succeeded beautifully by portraying Eagle, with strongly curved beak, as the wing of Raven. Together, they symbolize village unity.

Davidson had only two days in which to create the design and cut the screen for photographing, and the card was then commercially printed by lithography. This time he had the great satisfaction of being able to donate his work to the village.

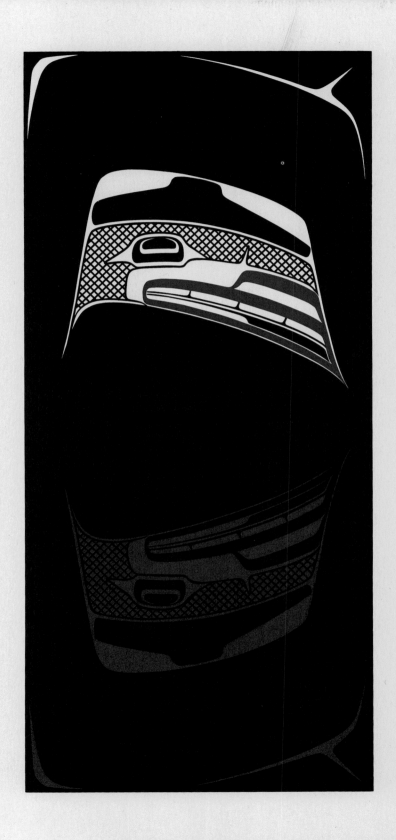

65 / Reflections
edition 75 / 32 x 57 cm / 1977

For the first exhibition of the Northwest Coast Indian Artists Guild, Davidson reworked his unusual 1975 Christmas card into a dramatic print.

Making it larger required greater refinement of the two faces. He also gave it an added subtlety, of which he was so fond: between the two main elements he printed a split U form in red on the black, knowing from past experience in overprinting the effect it would give.

Davidson named this print *Reflections* because he felt it expressed the way we perceive: when an artist depicts something, his design is an immediate reflection of what is seen, yet altered as a result of the mind's interpretation of it. The print shows two images, one a different coloured reflection of the other.

66 / Beaver
edition 74 / 51 x 12 cm / 1977

Davidson's next two printed works are indicative of his highly developed sense of design. Originally created for a silver bracelet, the motif of this print is a Beaver rendered in split form. In the centre is the standard beaver head with ears, eyes, nose and large incisor teeth.

The artist's originality comes through in his interplay of the negative and positive elements on either side of the design. From the head, strong form lines sweep down to outline the cross-hatched tail on either end of the split figure. They give the illusion of being the hind legs for the large webbed feet, but the white negative spaces just below can also be construed as being the hind legs. Beaver's front legs and feet are flexed on either side of the head.

67 / Wolf
edition 74 / 51 x 12 cm / 1977

The second of the two prints showing Davidson's harmony of design through juxtaposition is also derived from a silver bracelet. Its strength lies in its cohesive unity. The positive elements integrate with the negative spaces in a continuous flow from one end to the other.

Of secondary importance is the subject — a wolf. The traditional characteristics of the profile head in the centre show the flaring nostril, teeth and large ear. The rest of the animal is distributed within the rectangle to the point of abstraction, creating a fluid statement in a single unit.

Davidson enjoys "playing with form lines," interchanging negatives and positives, creating visual puns and illusions and other design variables. His ability to do this and retain design quality comes about through his thorough knowledge of the art and his facility in using it.

68 / Moon
200 printed / 15 x 18 cm / 1978

During the period that Davidson was exploring new ways of experiencing the two-dimensional art form, he tried out his Moon print in various colour combinations. Although he first conceived it as a three-colour design, the use of black, red and the blue-green did not please him at the time.

Later, wanting to complete the colour variations, he made deckle-edge cards using his original concept, and liked the result. Having missed the Christmas season for 1977, Davidson mailed the cards as belated New Year greetings — in March. His friends found greater pleasure in having the card then, than had they received it at the height of the season with so many others.

106

69 / Seal Bowl

edition 150 / 61 x 33 cm / 1978

A seal basking on a rock will often curve its back, raising its head and tail flippers in an attitude that suggests a shape for a carved bowl. This two-dimensional design recalls the elegantly carved wooden bowls used for serving seal oil at the lavish Haida feasts of the past; it also echoes the shape of the great canoes of these seafaring people.

The flow of the black and red composition within the contour of the seal form typifies how carving and painting were skillfully combined by many artists of the Northwest Coast.

This print was commissioned by the Vancouver Public Aquarium to commemorate the opening of a special pool for the display of harbour seals, and was sold only through the gift shop there. The Aquarium reproduced the design on its invitations to the event.

70 / Raven-finned Killer Whale

edition 75 / 42 x 28 cm / 1978

In front of the plank house where Robert Davidson's great-great-grandmother lived, there stood a memorial pole named Raven-Finned Killer Whale. An ancient legend tells of a Killer Whale chief who carried a raven perched atop his tall dorsal fin.

In recreating the legendary whale, Davidson has integrated its body with that of the raven. The bird's head forms the whale's dorsal fin, and its wing (connected by cross-hatching) becomes the pectoral fin. Their back-to-back heads form the blow hole, and they share a common tail.

This print was chosen for the Northwest Coast Indian Artists Guild Graphics Collection for 1978.

71 / Dogfish

edition 82 / 43 x 18 cm / printed 1975, issued 1978

In 1975 Davidson made his first three-colour print, introducing the traditional blue-green colour sometimes seen in Haida work. Although this colour is generally reserved for the tertiary areas of a work, it was used for the primary form line of the print. The design was based on his 1969 Christmas card, a split Dogfish, which he refined and improved, but the artist was not satisfied with the result and never released the completed edition of 300.

Still feeling that it was a strong design, Davidson again turned to the dogfish motif two years later, this time eliminating the use of the blue-green. He cut the required screens, had the design commercially printed, and released the edition the following year. He had wanted to simply give them away to the first seventy-five guests arriving at the opening of his recent exhibition, but he allowed outside influences to change his mind.

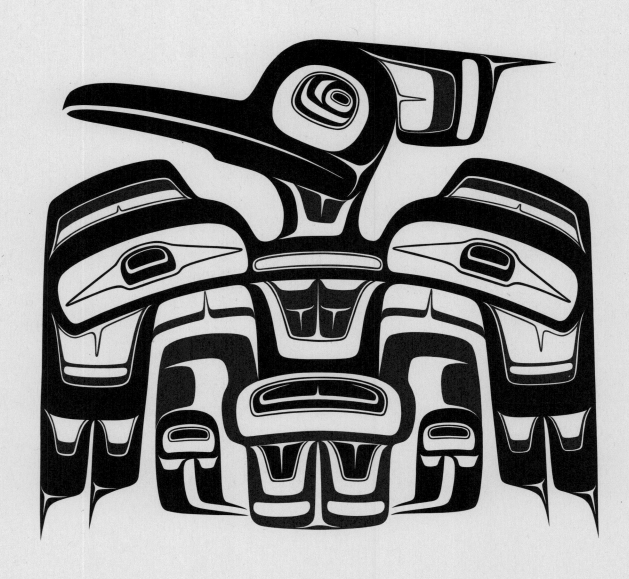

The composition of a hummingbird had been in Davidson's "ideas book" for eighteen months. He liked the scribbled idea, developed it linearly, and was pleased with it. However, the cutting of the screen brought solidity to the shapes, and the artist later recognized that the form lines were too heavy for so delicate a bird.

Davidson has added U forms to the wing-joint ovoids, and by using eyes in the ovoids he has deliberately created a face within the overall design: Humming Bird's body becomes the snout, and split U's resemble teeth. This form of visual punning is often found in sophisticated Haida designs of the past.

The ovoid used for the tail joint doubles as the hip joints to which the legs are attached. A departure occurs here when the upper line of this ovoid is interrupted by the black U form of the bird's body.

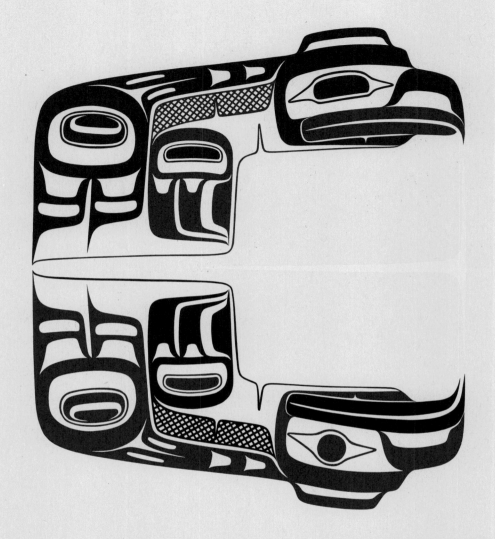

73 / Parnell Memorial: Eagle and Raven

344 printed / 36 x 39 cm / 1978

In a storm-swept sea up the coast, a fishboat capsized, drowning five men — brothers and cousins of the Parnell family who had moved to Prince Rupert from Old Masset. Frank Parnell, a son of one of the drowned men, asked Davidson to design a print for distribution at the memorial potlatch to be given for his relatives. Fully occupied at the time, and trying to meet a deadline, Davidson nevertheless sensed the importance of the request. It was an echo from the old days when an artist would be commissioned by a prominent person to create something. He felt a strong desire to design a print that would serve a deeper purpose than the commercial market, and somehow found time for it.

Because the drowned men were from both the Eagle and Raven moieties, the artist devised a way of showing both crests, something he had been called upon to do on two previous occasions. In this print, the top half depicts Raven in black form line, with a leg and clawed foot in red. The crest appears to be reflected, as in water, but the mirror image becomes Eagle by having a different beak. The red and black are transposed for a negative/positive effect, this opposition representing life and death — the living and dead of the family.

The third colour has been added subtly to symbolize the human spirit, which is not visible but has a definite presence. Prints with such subtleties reward the close attention of the observer.

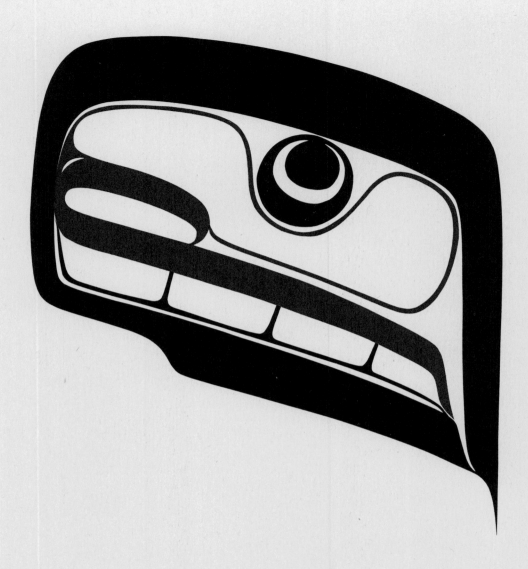

74 / Edenshaw Memorial Dedication Program

1000 printed / 14 x 18 cm / 1978

Davidson spent the summer of 1977 in his village, working on a major Federal commission, a memorial to his famed great-grandfather, Charles Edenshaw. With the full-time help of two apprentices, he carved and painted the entire front of a reconstructed Haida house, adapting an original Edenshaw design from a chief's seat.

To proclaim the house front a monument to this great artist, a bronze plaque was set in place and the dedication validated with a potlatch. Parks Canada had commissioned the project and therefore sponsored the feast and the customary gift giving, a two-day event held in November of 1978.

Davidson designed a card for the invitations that were to be sent,

but through a lack of communication the design became the cover for a program of events instead. Although government policy demanded that the card be printed in both English and French, in deference to the Haida-speaking people the brief biography of Charles Edenshaw (1839 - 1924) was translated into a written form of their language.

In many of his carved and engraved designs, Edenshaw used a small, distinctive profile face that became almost a trademark of his work, and Davidson chose this characteristic element for the cover design. One thousand were lithographed by Parks Canada, and the artist personally cut the screen to ensure its quality.

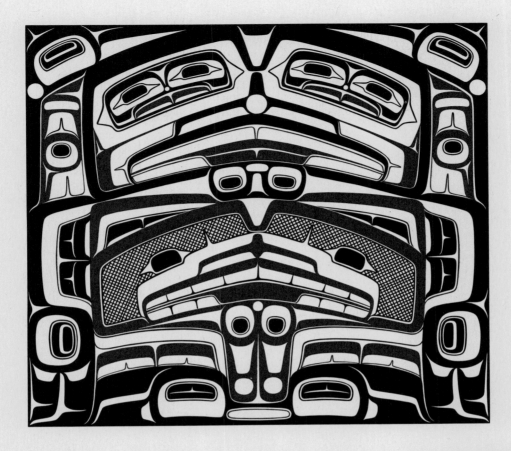

In November 1978, Robert Davidson held a one-man exhibition at the Bent-Box Gallery, Vancouver. The show included many of his earlier works as well as recent ones: carvings in wood and argillite, silver and gold jewellery, and prints. Prices on many items ranged well into the four-figure bracket.

His latest print, *Bent Box Design*, was appropriate for the invitation to the opening and for the posters that advertised the show. The gold card on which the posters were printed gave a richness to the work and answered the artist's desire to extend the colour range of his prints. The design was, he felt, a reflection of his self-awareness.

In the mid-seventies Davidson saw that he had an inner and an outer self, and expressed this awareness in *Transformation* (#49), but, significantly, the deeper inner self was shown as being covered by his outer shell. The years that followed brought him new strength and confidence through self-acceptance, and he no longer needed to suppress the feelings of his inner self.

In *Bent Box Design*, he visually acknowledged his dual self-image. Using red for the structure (form lines) of the inner figure and black for that of the outer figure, he melded the two by using the opposite colours on the areas of secondary importance.

It had been a decade since Robert Davidson first copied a simple one-colour line design and reproduced it on a small card by the silkscreen process without really knowing how. The years had brought him training, experience, knowledge, skill and, above all, continual development. Looking back now on those ten years he sees that he has moved through four levels of progression: imitative; elementary; exploratory, and expressive. In the first stage he imitated the works of others, copying their designs; at the elementary level he created his own designs but generally stayed within the realms of simplistic renderings of traditional figures; the exploratory level saw him investigating new ideas and experimenting with concept, colour and shape; now, at the expressive level, his works subconsciously portray his attitudes and feelings about his art, himself and his family.

The young artist still has many years ahead in which to further develop as an artist and a person. "I am not content to 'recycle ideas,' " says Davidson. "I recognize the need for continued growth and now feel I must go beyond the accepted limits of the art set by masters of the past. I want to expand my ideas and create boundaries that are my own."

In this one is reminded of his great-grandfather, Charles Edenshaw, and Bill Reid, his early instructor, both Haida artists who built upon the same vision.

Some Useful Definitions

Original screen print A silk screen is cut by the artist, or by a skilled person working from the artist's pencil drawing or other rendering, under the close supervision of the artist. Upon completion of printing, the artist selects, signs and numbers each print in the edition.

Edition The total quantity of prints signed and numbered by the artist, who thereby guarantees that no further prints were made except for artist's proofs and remarque prints.

Artist's proofs A small quantity, usually under ten, which the artist identifies A/P.

Remarque prints A small quantity, usually under ten, which the artist distinguishes from the main edition by making a small original sketch adjacent to his signature. These are not numbered.

Unsigned, unnumbered screen print Multiples of the same design executed by the artist or from his design under his supervision. Distinguished from a "reproduction" by virtue of the design's being executed exclusively for the screen print; that is, the print is not a copy of a painting or design; the original exists in the screen.

Alphabetical List of Prints

All sizes are given in centimetres. Bold face digits indicate print number.

Beaver 1969 33 x 43 **8**

Beaver 1972 17 x 20 card **22**

Beaver 1974 29 x 32 **39**

Beaver 1978 51 x 12 **66**

Benjamin's Birth Announcement 1976 29 x 32; 14 x 18 card **56**

Bent Box Design 1978 50 x 46 **75**

Bentwood Box 1973 44 x 8 Christmas card **38**

Butterflies 1977 57 x 32 **63**

Change of Address 1971 15 x 18 card **21**

Chest End Design 1970 37 x 46 **15**

Dogfish 1969 36 x 42; 46 x 51 **7**

Dogfish 1969 22 x 10 Christmas card **11**

Dogfish 1971 24 x 70 **19**

Dogfish 1974 29 x 32 **42**

Dogfish 1978 43 x 18 **71**

Eagle 1969 36 x 46 brochure cover **5**

Eagle: Oliver Adam's Potlatch Invitation 1976 14 x 18 card **53**

Eagle: Oliver Adam's Potlatch Gift 1976 36 x 41 **54**

Eagle 1977 20 x 20 **59**

Edenshaw Memorial Dedication Program 1978 14 x 18 program cover **74**

Exhibition Invitation 1971 17 x 12 card **20**

Feather Designs (5) 1972 18 x 53 **25/26/27/28/29**

Four Circles — Raven, Eagle, Whale, Frog 1977 20 x 20 **58/59/60/61**

Frog 1968 13 x 17 card **1**

Frog 1974 29 x 32 **41**

Frog 1977 20 x 20 **61**

Grizzly Bear 1973 24 x 51 **36**

Human 1971 29 x 64 **17**

Hummingbird 1978 56 x 56 **72**

Killer Whale 1969 10 x 13 Thank-you card **4**

Killer Whale 1970 33 x 43; 33 x 51; 41 x 51 **14**

Killer Whale 1970 17 x 20 Christmas card **16**

Killer Whale 1973 29 x 32 **34**

Killer Whale 1975 15 x 44 **44**

Killer Whale 1977 20 x 20 **60**

Killer Whale Fin 1973 28 x 64 **35**

Marriage Announcement 1969 14 x 18 card **3**

Moon 1976 black and blue-green on beige, 43 x 43 **50**

Moon 1976 red and blue-green on black, 43 x 43 **51**

Moon 1976 blue-green on black, 43 x 43 **52**

Moon 1978 15 x 18 New Year card **68**

Mother's Memorial 1973 27 x 46 **37**

Negative and Positive 1975 10 x 22 Christmas card **48**

Ordination Invitation 1977 14 x 18 card **64**

Parnell Memorial: Eagle and Raven 1978 36 x 39 **73**

Pole-Raising Potlatch Invitation 1969 16 x 13 card **6**

Pole-Raising Potlatch Gift 1969 36 x 43 burlap **6a**

Pole-Raising Potlatch Gift 1969 36 x 43 paper **6b**

Raven and Fetus 1973 29 x 32 **31**

Raven-Finned Killer Whale 1975 13 x 56 **47**

Raven-Finned Killer Whale 1978 42 x 28 **70**

Raven Stealing the Moon 1977 43 x 77 **62**

Raven with a Broken Beak and the Blind Halibut Fisherman 1971 24 x 70 **18**

Raven with Broken Beak 1973 29 x 32 **33**

Raven with Broken Beak 1974 14 x 18 Christmas card **43**

Raven with Broken Beak 1975 35 x 28 **46**

Raven with Broken Beak 1977 20 x 20 **58**

Reflections 1977 32 x 57 **65**

Sara's Birth Announcement 1973 29 x 32; 14 x 18 card **32**

Sea Bear 1968 13 x 16 card **2**

Sea Bear Box Back 1969 50 x 65 **10**

Sea Bear Box Front 1969 50 x 65 **9**

Sea Ghost 1974 29 x 32 **40**

Sea Monster 1976 37 x 37 **55**

Seal Bowl 1978 61 x 33 **69**

Split Beaver 1975 29 x 32 **45**

Thunderbird 1970 36 x 46 **12**

Thunderbird 1970 36 x 46, two-colour **13**

Transformation 1976 14 x 17 Christmas card **57**

Untitled 1972 14 x 18 Christmas card **30**

Wedding Invitation 1976 14 x 18 card **49**

Wolf 1978 51 x 12 **67**

Wolf Box, Back 1972 61 x 42 **24**

Wolf Box, Front 1972 61 x 42 **23**